A Split Second
of Paradise

Live Art, Installation
and Performance

Edited by Nicky Childs
and Jeni Walwin

Rivers Oram Press

London and New York

First published in 1998 by
Rivers Oram Press
144 Hemingford Road
London N1 1DE

Distributed in the USA by
New York University Press
Elmer Holmes Bobst Library
70 Washington Square South
New York NY10012-1091

Set in Gill Sans and Gill Sans Bold
and printed in Great Britain by
Hillman Printers (Frome) Ltd
Designed by John Gibbs

British Library Cataloguing in
publication data
A catalogue record for this book is
available from the British Library

ISBN 1 85489 098 0 (cloth)
ISBN 1 85489 099 9 (paperback)

A Split Second of Paradise

Contents

Preface

There is growing interest in live art, installation and new performance in Britain. The area of work is attracting large audiences and is generating a following amongst people who are interested in new cultural trends, who follow new fashions, who are interested in new music and who perceive connections between many aspects of the contemporary world and live art. Very little has been written about it, in spite of an increasing commitment to the field. Artsadmin has therefore commissioned a publication which focuses on new performance, live art and site-specific projects, unravels significant aspects of the practice and targets the expanding audience.

The central aims of the project are to raise awareness and understanding of current live-art thinking through a written study of the work of seven leading practitioners. We have commissioned texts that aim to reach a wider audience than that traditionally associated with contemporary fine art and theatre.

The writers have worked closely with the artists on initial research and have created a wider context for the understanding of their work, making comparisons and connections across the contemporary cultural scene. The matching of artist and writer has been carefully considered and we have invited writers who can prise the work out of its sometimes tightly defined corner and offer new insights and new strategies for considering its relevance.

Nicky Childs and Jeni Walwin
Editors

Artsadmin

Since 1979, Artsadmin has worked with over seventy artists and companies in the support and development of their work. The organisation provides a comprehensive management service and unique national resource for contemporary live artists working in new theatre, dance, music, live art and mixed media work. It supports, develops and promotes artists' work by providing efficient, affordable and continuous management, from the initial stages of a project through to its final presentation, seeking to establish partnerships with producers, promoters and relevant arts organisations in Britain and abroad in order to bring the work of its artists to a wider public. At Toynbee Studios Artsadmin provides a centre for the creation and development of new work, offering theatre, workshop, rehearsal and research space in Spitalfields, East London.

Artsadmin also runs an Advisory Service for emerging and unfunded artists and operates Resource, which gives artists an opportunity to develop new ideas over short periods using the spaces at Toynbee Studios. This publication is a new departure for Artsadmin, and features a selection of the wide variety of artists associated with the company in recent years. Taken as a group, the artists reflect Artsadmin's continuing commitment to the development of new and challenging work.

Judith Knight
Director, Artsadmin

The Contributors

Sacha Craddock studied painting at St Martin's School of Art and Chelsea School of Art. In her capacity as an independent art critic, she writes catalogue essays and magazine articles, maintains a column for *The Times* and gives regular public lectures.

Tim Etchells is an artist who makes work in theatre, writing, performance, installation and film. Best known for his work as writer and artistic director of Sheffield-based performance ensemble Forced Entertainment (formed in 1984), he has also published fiction and theoretical and critical papers in a wide variety of contexts including *Performance Research* and *frieze* magazines. Etchells recently co-directed a short film, *DIY*, for Channel 4.

Sarah Kent is best known as the visual arts editor of *Time Out* magazine and as a broadcaster. She studied painting at the Slade School of Fine Art and has an MA in Art History from University College, London. For many years she has pursued her own work and lectured part-time at art schools. She gave up teaching and began writing in 1976 and was Director of Exhibitions at the ICA, London from 1977 to 1979. She has curated many exhibitions and written numerous catalogue essays. Her books include *Women's Images of Men* with Jacqueline Morreau (1980, 1985) *Shark Infested Waters* (1994), a discussion of the young British artists in the Saatchi Collection, and *Stephan Balkenhol: Sculpture* (1996).

Naseem Khan is a writer and arts consultant concentrating on emergent work. She was theatre editor of *Time Out* in the 1970s when the Fringe was in the process of rapid development and wrote on the 'Other Theatre' for the *Evening Standard*. Subsequently, she wrote the first report into Britain's 'Ethnic Arts' – *The Arts Britain Ignores* – and established MAAS as a national umbrella body for practitioners. In the 1980s she wrote a weekly column for the *New Statesman and Society* for three years. Called 'Work In Progress', it was able to explore issues and developments in cultural life and policies – from the dynamics of carnival to the sea-change in community arts – that review columns could not cover.

Deborah Levy is the author of four novels: *Beautiful Mutants* (1987), *Swallowing Geography* (1991), *The Unloved* (1994) and *Billy Girl* (1997). Her texts for the theatre include *Honey Baby, 13 Studies In Exile* (Lamama, Melbourne), *Call Blue Jane* (with ManAct Theatre), *The B File* (Chapter Arts), *An Amorous Discourse In The Suburbs of Hell* and *Bleeding The General* which started its life as a collaboration with playwright and poet Howard Barker. In 1998, the film *Suburban Psycho* for which she wrote the screenplay, will be screened on BBC1.

Yve Lomax is a visual artist and writer. She studied at St Martin's School of Art and the Royal College of Art. She lives in London and teaches at Central St Martin's, Goldsmith's College and Surrey Institute of Art and Design. Her work has been exhibited widely and regularly including, most recently, *Trope – Image & Voice*, a collaborative work with Vit Hopley. Her writings have been published extensively, including 'Folds in the Photograph' (1995), contributions to *Make*, the magazine of women's art, and 'A Few Words', *Interior Light, Lynn Silverman Photographic Book* (1997). Recently, she has developed the practice of performing her text. She gives performances at numerous venues both nationally and internationally.

Lynn MacRitchie is a freelance art critic, writer and artist based in London. She writes regularly on contemporary art for the *Financial Times*, contributes to the *Guardian* and is London correspondent for *Art in America*. A former editor of *Performance* magazine, she has a long-standing interest in art which breaks boundaries and has written about performance, dance, video and installation. She has published essays on the work of Marina Abramovic and Rose English.

Andrea Phillips is a lecturer and research fellow at Dartington College of Arts, Devon and is based in London. Her writing on visual and performance art appears in numerous artists' catalogues and journals including *Performance Research*, *Circa*, *Artists' Newsletter*, *Coil*, *Dance Theatre Journal*, *High Performance*, *Performing Arts Journal* and *Versus*. In 1992, she co-founded and edited *Hybrid* magazine. Currently a contributing editor to *Performance Research*, she also chairs and gives papers at conferences nationally and internationally.

Marina Warner is a writer, critic and historian. She studied at Lady Margaret Hall, Oxford. Author of three praised studies of mythology, she has also published four novels including *The Lost Father* (shortlisted for the Booker Prize, 1988 and regional winner of the Commonwealth Writers' Prize) and *Indigo*, as well as biographies, short stories and children's books. In 1993 she published her first collection of short stories *Mermaids in the Basement*, followed by *Wonder Tales* and her study of fairy-tales *From The Beast to the Blonde*. She has also written the libretto for the opera *In The House of Crossed Desires*, which premiered at Cheltenham Festival of Music in 1996 and curated, with the Hayward Gallery, the touring exhibition *The Inner Eye: Art Beyond the Visible* (1996).

Heather Ackroyd studied sculpture and performance at Crewe
and Alsager College. Between 1980 and 1993 she worked with a
number of performance practitioners and made work with Impact
Theatre Co-operative, The People Show, Graeme Miller, Gary
Stevens and most recently the RSC. **Daniel Harvey** studied fine
art in Cardiff and at the Royal College of Art. Exhibiting extensively
in England and Europe, his works are in both public and private
collections. He has also worked within film, on design, object mak-
ing and special effects; notably for the British directors Derek
Jarman and Peter Greenaway.

Since 1990, Ackroyd and Harvey have worked collaboratively on a
number of sculpture and installation projects. Using seeds and crys-
tals and other diverse materials, these act upon surfaces and
change when exposed to the effects of moisture, air or light. With
the exception of two presentations in Hull and London their work
has been seen almost exclusively outside the UK. *Implanted Spirit*
and *The Undertaking* were commissioned for Les Arts Etonnants, in
France in 1991-2. Further major commissions have included
Theaterhaus Gessnerallee (Zurich, 1993), *Force Field* for Galway Arts
Festival (1993). *89–91 Lake Street* for the Perth Festival (Australia,
1994), *The Divide* for the New Zealand International Festival of the
Arts (Wellington, 1996) and *Host*, an architectural collaboration
for the Nuova Icona Gallery in Venice, 1996. In 1997 they were
awarded a Sci-Art grant from The Wellcome Centre for Medical
Science to develop their work on photographic photosynthesis in

collaboration with scientists at the Institute for Grassland and
Environmental Research in Aberystwyth.

14

Bobby Baker trained as a painter at St Martin's School of Art and
began working with food and performance in the early 1970s. In
1976, she presented *An Edible Family in a Mobile Home* when she
opened her prefab in Stepney to the public and invited them to
consume a life-size, artist-made, cake family. This was followed by
the creation of the history of modern art in sugar, and an attempt
at a world tour dressed as a meringue. At the 1979 Hayward
Annual she served the audience with a meticulously prepared
Packed Lunch. In 1980 she had the first of her two children and
took part in *About Time* at the ICA (London) and the Arnolfini
(Bristol).
From then on Baker did no public work until 1988 when she first
performed *Drawing on a Mother's Experience* which told the story of
the previous eight years. In 1990 she first toured *Cook Dems* to
Glasgow and the Strathclyde region and opened her own London
kitchen to the public for *Kitchen Show*, winning the *Time Out*/Dance
Umbrella Award in 1991. This was to be the first in a five-part
series of performances entitled *Daily Life* and was followed by *How
to Shop* (1993) and *Take a Peek* (1995). *Jelly Game* and *Box Story* are
both in development for 1999. Since 1989 Bobby Baker has toured
all these shows both nationally and internationally, to mainland
Europe, North America, Australia and New Zealand.
In addition to her performances, Baker completed a film for BBC
television, *Spitting Mad*, broadcast in 1997, and she is working on a
publication with Adrian Heathfield which will document her new
work, *Table Occasions*.

Rose English studied fine art at Leeds Polytechnic. Since 1974 she
has made many solo and collaborative performances which have
been seen throughout the UK and abroad. She treads a careful
tightrope between art and entertainment and makes innovation an

idea that everyone can be comfortable with, cloaking experimentation with humour and turning outrageousness into solicitous grace. Among her most notable early works were *Berlin* (1976) in collaboration with Sally Potter for the Sobell Sports Centre Ice Rink and the Swiss Cottage Swimming Baths, and *Plato's Chair* which toured throughout Canada and Britain in 1983. For *The Beloved* (1985), *Thee Thy Thou Thine* (1986), and *Moses* (1987) she introduced children and, in some instances, animals into her performances which were seen in Britain and Europe.

Walks on Water at the Hackney Empire, London in 1988, marked the first of her large-scale theatre works. This was followed in 1991 by *The Double Wedding* presented at the Royal Court Theatre, and in 1992 *My Mathematics* for the Queen Elizabeth Hall, Sadler's Wells Theatre, Lincoln Center, New York and the Brighton Festival. *Tantamount Esperance* was presented for Barclays New Stages at the Royal Court Theatre in 1994.

Throughout her career, Rose English has collaborated with others in work for film, television and the theatre. In particular she co-wrote and designed the feature film *The Gold Diggers* with Sally Potter in 1983. She has also performed in productions at the Old Vic and English National Opera for Tim Albery and Richard Jones. In 1995, Rose English was awarded a Research Fellowship at Wimbledon School of Art. She is currently developing a large-scale performance involving seven horses and an ancient Bulgarian Orchestra, entitled *Rosita Clavel*.

Keith Khan studied fine art at Middlesex Polytechnic. His early performance works were presented in clubs in New York and Rotterdam and at the National Review of Live Art in Glasgow. He has had solo exhibitions at the Bluecoat Gallery, Liverpool and the Harris Museum and Art Gallery, Preston.

Khan has worked as a designer for Welsh National Opera, Shobana Jeyasingh, the London Bubble and Opera North. His television design work includes: *On the Other Hand*, *The Dazzling Image* and

We the Ragamuffin (for Channel 4), *Bideshi, Diwali Lights* and *Flight* (for BBC2) and *Sweet and Spicy* (for Carlton). For nine years he has designed for both the Notting Hill and Trinidad Carnivals. He has also curated programmes of performance, most notably *Quick* at the South Bank Centre, and two seasons of *Respect* at the ICA. The platform for most of his recent work is Moti Roti, a company established with the artist Ali Zaidi. Moti Roti makes work for theatres, galleries and outdoor sites, and has a long-standing relationship with the Tamaseel Theatre in Pakistan where the work that Moti Roti produced with them has been running for eight months. Major Moti Roti productions have included *Wigs of Wonderment*, commissioned by the ICA in 1995, and subsequently presented during the Copenhagen City of Culture Festival, 1996; *Maa*, a Barclays New Stages commission at the Royal Court Theatre in 1996; *Captives*, commissioned by Walsall Museum and Art Gallery and Walsall Illuminations in 1994; *Moti Roti, Puttli Chunni* presented at the Theatre Royal Stratford East and on tour in 1994 and *Flying Costumes, Floating Tombs*, a large-scale outdoor community project presented by the Arnolfini, Bristol and the 1991 London International Festival of Theatre. These last two projects won *Time Out* London Dance and Performance Awards.

In 1997 the company presented a new work at the Festival of Art and Ideas in New Haven, Connecticut, collaborated on *Madhurasha*, a participatory performance piece staged at the Royal Albert Hall and *One Night,* premiered at the Theatre Royal Stratford East.

Graeme Miller studied languages at Leeds University. He was a founder member of Impact Theatre Co-operative, whose work at the time of the company's disbanding in 1986, stood at the forefront of British avant-garde theatre. During the time with Impact, Miller worked as performer, composer and author of some twenty two productions including *The Carrier Frequency*.

In 1987 he composed and directed *Dungeness: The Desert in the*

Garden which was commissioned by the ICA and subsequently
toured in Britain and Europe. His second work *A Girl Skipping*
opened at the Place Theatre in 1989. It won awards from the
Barclays New Stages scheme and a *Time Out*/Dance Umbrella
Award as one of the best performances of 1989. In 1990 the show
toured for a second time in Britain, and to Seattle, Montreal and
New York. In 1992 Miller created *The Sound Observatory* for the
Sounds Like Birmingham City of Music programme. This was a
sound installation – part map, part sculpture, part music – which
offered visitors an aural and visual glimpse of the life of the city. *The*
Desire Paths toured in Britain and France in 1993 and was seen at
the Royal Court Theatre as part of the LIFT and Barclays New
Stages Festival.

In 1994, Miller was commissioned by Artangel and the Salisbury
Festival to produce *Listening Ground, Lost Acres* a collaborative pro-
ject with artist Mary Lemley which traced the landscape around
Salisbury in sound and sculpture. In 1996 he completed another
sound project *Feet of Memory, Boots of Nottingham* which was com-
missioned by Barclays New Stages and created with people from
Nottingham for broadcast on BBC Radio Nottingham. Continuing
the themes of place and memory, Graeme Miller has begun
research into a new sound project documenting an area in East
London which was demolished in 1995 to build the M11 Link Road.

Station House Opera was founded in 1980 as a group of fine
artists working in performance. Whilst the company has collabo-
rated with a number of artists and performers over the years,
Julian Maynard Smith has remained its artistic pivot.

Natural Disasters was shown at Acme Gallery, London and at the
Mickery Theatre in Amsterdam in 1980. *Drunken Madness* was
made for Waterloo Studios in 1981 and then commissioned by
Creative Time for the Brooklyn Bridge Centenary in 1983. *Sex and
Death* premiered at the International Symposium of Performance
Art in Lyon in 1981 and was subsequently reworked for the British

Art Show tour in 1984. *Ultramundane* and *Scenes from a New Jericho* were seen across the UK, in New York and in Europe between 1983 and 1986. *Cuckoo* toured extensively throughout Europe between 1987 and 1990. The company is particularly renowned for its series of architectural performances using breeze blocks. The first, *A Split Second of Paradise*, was commissioned by the Midland Group, Nottingham in 1985 and was then presented by Artangel in 1986 in a Venice piazza. *Piranesi in New York* was commissioned by Creative Time for the Brooklyn Bridge Anchorage, presented at the First New York International Festival of the Arts in 1988, and in the following two years was seen in Melbourne and reworked in Japan as *Piranesi in Tokyo*. These two projects paved the way for the most ambitious, *The Bastille Dances,* which premiered at Cherbourg's Gare Maritime and was subsequently presented on London's South Bank as part of LIFT'89 and then toured to Salzburg, Amsterdam and Barcelona. Station House Opera was the only British company to be commissioned to make work in celebration of the French bicentenary.

Following Julian Maynard Smith's Kettle's Yard Fellowship at Cambridge University in 1993, the company developed *Limelight*, a production based on pre-electric forms of lighting, which was one of the opening events of Copenhagen City of Culture Festival 1996. Two further architectural projects were commissioned, *Dedesnn-nn-rrrrrr* sited in front of the city's famous Frauenkirche for the Theater der Welt in Dresden and *The Salisbury Proverbs* sited outside the cathedral for the 1997 Salisbury Festival.

Gary Stevens studied fine art at Goldsmith's and the Slade School of Fine Art. Since 1984 he has been producing performance for a range of galleries, theatre spaces and festivals in this country and abroad. Many of these projects (*Invisible Work*, 1984-6, *If The Cap Fits*, 1985-8, *Different Ghosts*, 1987-8, *Animal*, 1989-90, *Name*, 1991-3 and *Sampler*, 1995) involved collaborations with artists from other disciplines. The performances developed from extensive

practical work in the studio, with a text that functioned both as description and commentary on a theatrical event rather than to establish characters.

Since 1993 Stevens has been commissioned to create a number of one-off performances for specific contexts. These include *Simple* for the Serpentine Gallery, *Time Piece* for Bookworks which was presented in the National Art Library at the Victoria and Albert Museum, *Blink* for De Montfort University, *Stuff* for Court In The Act Festival at the Royal Academy of Arts and *Take*, performed at Oxford Town Hall for the Ruskin School of Art. His work has been included in the Sydney Biennale (*If the Cap Fits*) and The British Art Show (*Animal*). *Sampler* was premiered at the Barclays New Stages Festival in Nottingham in 1995 and shown at the ICA theatre as part of the London International Festival of Theatre. His most recent work *And* was an installation for a gallery involving ten per-formers and was performed at the South London Art Gallery in 1997. In 1996 Gary Stevens received an award from the Foundation for Contemporary Performance Art (New York). He has also taught in the fine art department at Goldsmith's College since 1988.

The Sincerity of Events

Lynn MacRitchie

For almost a century, some artists have found asking questions about the process in which they are engaged to be a necessary part of their work. Their continuing re-evaluation not only of its form and content but also of art's relationship to the wider social and political realm has become an established strand of contemporary cultural discourse. Within this context, work which came to be called live or performance art emerged most powerfully in Europe and the United States at moments of artistic or social crisis, when formal aesthetic or social structures were perceived to be inadequate or had actually collapsed.

The Europe of the first three decades of the century, living through the first and approaching the Second World War, and then the United States of America, first in the glow of its 1950s prosperity and later during the trauma of Vietnam and the social fracturing which followed, have all produced flowerings of live work. Its most fruitful period in the UK began later, in the 1970s, when most of the artists considered in this book were just starting out on their careers. By then, performance had accompanied the political upheavals in 1968 Europe, assisted at the emergence of feminism, watched the US lose the Vietnam war. In the UK, its radical roots kept it steadfast in the face of the philistinism of the 1980s when the City of London had its Big Bang and property prices boomed. When the boom collapsed, live art survived in the ruins, animating empty warehouses and factories, fleetingly peopling empty office blocks. In the 1990s it lives on, quieter, more assimilated, with a

history of its own to help shape its future.

For the artists described in this book, whose careers began in the 1970s, as for none before, the body of live work produced over the preceding sixty years was available to those who sought it out as an alternative academy, parallel to the familiar art school disciplines of drawing, painting and object-making. A canon of contemporary live work existed – the New York Happenings organised by Allan Kaprow and Claes Oldenburg, Jim Dine and Robert Rauschenberg and the later activities in the US and in Europe of the Fluxus group were well know. Articles and texts were available – John Cage's 'Silence' and the I Ching were popular – and underground films by Andy Warhol or Yoko Ono and many others could be seen in film societies or clubs. In Europe, there was a new hero, Joseph Beuys, to emulate or oppose. Performance was out there, waiting, live art was cool. Julian Maynard Smith describes the beginnings of Station House Opera as 'sailing into the theatrical world from art school, without baggage, without self-consciousness'. In doing so, Station House Opera and its contemporaries were allying themselves with a tradition of expectation that going live would allow their work access to areas of experience only available within the lived moment, their integrity of purpose guaranteed by the impermanence of its expression. By appearing not to care about permanence, performance art made immanence its watchword, its immediacy a guarantee of the purity of its intentions.

Performance art has always had integrity at its core. Armed with little more than its immediacy, live art has made sweeping claims. Hugo Ball set up the Cabaret Voltaire in Zurich in 1915 to remind the world that 'there are independent men beyond war and nationalism who live for other ideals...' Those independent men and women, putting on skits and sketches, declaiming nonsense rhymes and wearing crazy costumes had a clear and stated purpose: 'to contradict the existing world order'. Their faith that they could, indeed would, do so was founded in their fundamental belief in the ultimate truthfulness of lived experience over any established acad-

emic practice or political theory. 'The Dadaist', Hugo Ball wrote, 'trusts more in the sincerity of events than the wit of persons...' In wartime Zurich, when 'this world of systems has gone to pieces', only the lived experience of the moment, the product of physical, sensual response rather than intellectual contemplation, was fit to be trusted. Such faith in the truth of experience has remained a guiding tenet for the subsequent development of live work.

It has also placed a burden of shared responsibility on performer

Joseph Beuys, *Coyote II* (1980) © DACS 1997, courtesy of Anthony d'Offay Gallery, London

and audience. Live art is made possible only by a pact of good faith: for whatever is presented, whether it be the actions and discussions of Joseph Beuys, the silent concerts of John Cage, the terrifying rituals of Hermann Nitsch or the bodily ordeals of Marina Abramovic, requires the presence and sometimes the direct intervention of the audience to become a complete work of art. Knowing their witnessing to be an essential part of the aesthetic whole, audiences, however shocked or uncomfortable they might find themselves, did

not need to fear being duped.

It had not always been so. The audience's part at Futurist events in Turin and Milan from 1910 to 1914, or the Dada cabarets of Zurich and Berlin two years later, was to be jeered at, assaulted, mocked and reviled as representatives of bourgeois decadence and conformity. It was only in the years following the Second World War that the potential of the audience as a participant in the creative process began to be explored, as part of the more general desire to break down the boundaries between art and life, to 'promote living art, anti-art, non-art reality to be grasped by all peoples, not only critics, dilettantes and professionals...' as George Macuinas wrote in the Fluxus manifesto of 1963. Later, when the early happenings and mass participation events had largely given way to the individualised experiments of body art, practitioners such as Marina Abramovic would speak of how important a part the energy flowing to her from the attentive audience played in enabling her to sustain the pain and exhaustion of the ordeals to which she subjected her body in their presence.

The work of the artists here described does not deal in such extremes. Rather, for them, to work live was a natural extension of their work in more conventional media. Bobby Baker describes how drawing and painting could not contain the power of her feelings, which she was compelled to express in person, almost as if preaching from a soap box. Rose English was fascinated by the power of objects: creating ever more beautiful and strange things – shoes made from horses hooves to take just one example – she began to make scenarios with dancers and other performers in which her objects could be presented with appropriate resonance. Her subsequent performance and latterly large scale theatre work has consistently explored the mystery of theatrical illusions and effects. Keith Khan trained as a sculptor but moved into creating costumes for public art and carnival pieces and eventually to writing his own multimedia work for the theatre. Julian Maynard Smith of Station House Opera trained as an architect and became a choreo-

grapher of breeze blocks in a scenario of shifting architecture 'inspired by Tintoretto'.

In mixing elements in this way, these artists are upholding one of the most significant tendencies of the art of this century, the breaking down of boundaries within and between media. An epoch which has embraced the invention and popularisation of film, television, video and computer technology has found artists refusing to stay confined within one medium when others, equally exciting, were beckoning from the sidelines. They were eager to seize the possibility of enriching one medium with the forms of another: the contempla- tion of the visual image, for example, now as a matter of course extended to watching television. For these artists, enjoying nostalgic old movies on Sunday afternoons or speeding through music videos on MTV, it was natural to seek meaning not within but between a mélange of different forms of expression, 'a resolutely anti-hierarchical conception of the production of meaning', as Barthes put it. Or, in the words of Keith Khan, describing his own working process, seeking 'maximalism rather than minimalism...making direct imitations of cultural icons, lifting powerful images and claiming them in my work.' Once appropriated, these could work as 'infiltrators', mixing 'messages about religion, gender, race in an everyday setting'. This joyful 'maximalism' represents an important break with the position of the mid-1970s, when the British fine art/performance nexus was intrinsically hostile to theatricality. Rose English, who began working in performance at this time, has talked of how she used to think that acting was 'lying' and that the concept of illusion was 'anathema, summing up everything that was despicable about theatre'. For 'pure' performance artists – and none were purer than they – the process of doing the work was almost more significant than that which was actually done, the live nature of the work, its actuality, valued more highly than any particularity of content or style. The artist, not the audience, was the judge of the work's aesthetic merit, performing in 'real time' that is, the time it took for the artist, not the audience, to consider that the work had achieved

aesthetic completeness.

This tendency was partly owing to the alliance of the more 'cool' forms of performance (to use Gray Watson's term) with conceptual art. Artists could choose to use their bodies as well as any other materials to demonstrate conceptual investigations of time, place or process. In such work the body was not presented *per se*, as in body art, but was merely another tool to demonstrate the conceptual framework of the artist's ideas. Bruce Nauman, Dennis Oppenheim and Klaus Rinke, for example, all worked in this way. Body artists, on the other hand, used performance as a means of catharsis, some such as Hermann Nitsch, Gunther Brus or Gina Pane seeking a ritualised expurgation of fear, shame and guilt, others such as Marina Abramovic and Ulay or Chris Burden an experience of transcendence achieved by pushing the body to its limits of pain or endurance. In England, Stuart Brisley's work made clear links between the physical endurance of suffering and humiliation and the alienation of the individual in society. Performance by women artists, who turned to the medium in considerable numbers in the mid-1970s, tended to place itself somewhere between the two. Exposing themselves as women in the arena of live performance allowed women artists also to expose the act of looking itself, and by questioning and breaking it down, to begin to find a new identity as active manipulators of the visual world rather than its victims.

The intense political questioning of the 1970s, when everything – social structure, economics, the family, race, academies of all kinds, languages, gender, sexual behaviour – was looked at anew also infiltrated the art world. What was art? What was its relation to politics? Was a democratic approach to the making of an artwork more important than the quality of the art which resulted? What role did race or gender play in the process of making art? Was there somewhere art could be presented free from the expectations set up by art gallery or theatre spaces? While the rigour of the examination produced some performance work of exceptional strength and

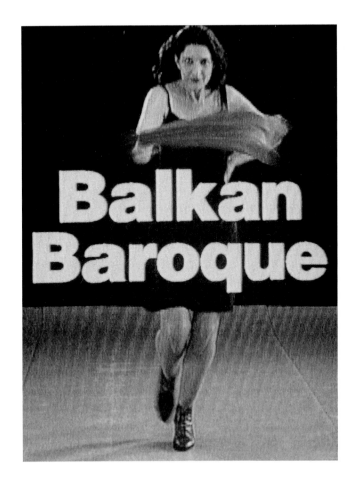

Marina Abramovic, *Balkan Baroque*,
Venice Biennale (1977)
Photo: © Marina Abramovic,
courtesy Sean Kelly Gallery,
New York

power, its intensity was such that the process ultimately could not be sustained. Gradually, the extreme purity of intense questioning gave way to a more inclusive position.

This coincided with the realisation that the economic good times were at an end. When boom tipped over into recession, the art world was hit and hit hard. It was no longer necessary to mimic suffering and abjection when people were sleeping in boxes in the street. As the manufacturing and distribution which had once powered urban centres went into terminal decline, artists took over derelict factories and warehouses as playgrounds for a creativity that mourned a lost past while shying away from conceptualising a future. Once again, the purity of the moment was all that could be

relied on, the promise of performance the only one that had not been broken.

In the bleak times of the 1980s and early 1990s, a happy ending could no longer be assumed. Rose English expressed her frustration with this state of affairs in the words of Tantamount Espérance, the lead character in her work of the same name. 'I have been waging a personal war on nostalgia...on what I perceive to be an inability to embrace an idea of a future.' Only the fleeting impression of the moment could be relied on, held on to when everything else was shifting and uncertain. By making use of their 'location of deliberate marginality' as Graeme Miller described it, as a strategy to 'refuse erasure', and by recognising uncertainty as opportunity and a means of releasing creativity, Miller, English, Gary Stevens and others created in their work those 'split seconds of paradise' which brought audience and performer together in a shared glimpse of something greater than themselves. Beautiful or terrifying, raging or serene, the moment of rapture became the shared goal of performer and audience alike.

Such work might seem very far from the early days of declaiming manifestos and marching in the streets. Removed in time and space, certainly, but not so very far from the heart. The broadly transformative artistic and political programmes of the Futurist, Dada, Surrealist and Constructivist movements all called for artists to take a leading role in the creation of a new and better world which would rise from the destruction of the old. The real and terrible destruction wrought by two world wars had made a mockery of any idealisation of violent social change, however, and the development of live work post 1945 followed a dual path. While continuing to expand and explore its original premise of the critique of the position and purpose of the art object and the academic institution, artists' own bodies, their physical being, came to be considered as a site of knowledge and a vehicle for affecting healing and transformation.

Performance has in and of itself developed into a means of thinking,

the performative process an exemplification of the workings of the mind. 'Doing' art – think of Jackson Pollock, in his black jeans, cigarette in mouth, intent, cool, splattering paint down on those canvases and dancing Abstract Expressionism – makes thinking physical, an experience, sparking connections, unexpected understandings. The canon of live work has now unarguably demonstrated that performance can have the power and resonance of traditional forms of theatre, and might indeed make use of some or

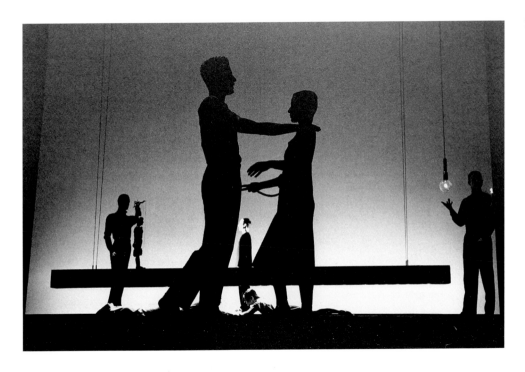

Robert Wilson, *Dr Faustus Lights the Lights*, Edinburgh (1993)
Photo: Geraint Lewis

all of them (music, dance, words, light) while turning them into something entirely new, something to be experienced purely on its own terms.

Robert Wilson's *Einstein on the Beach* of 1976 was a key example of this kind of performance piece. Running for more than five hours, it brought together composer Philip Glass, choreographers Lucinda Childs and Andrew de Groat and a large cast of dancers and artists working with texts written by the autistic young man Christopher

Knowles. Wilson himself designed the massive sets: the wall of light boxes and his own mad dance with a light bulb had many subsequent imitators. Wilson called the work an opera, an accurate use of the term in its Wagnerian sense of total artwork. In the subsequent twenty years, Wilson has become a hugely influential figure, continuing to produce his own work while also working prolifically as a director in the theatres and opera houses of Europe.

As the end of the twentieth century draws near, it seems clear that the interrelationship of all types and forms of artistic activity pioneered in performance art has become the dominant mode of expression of the era. When, in 1917, Marcel Duchamp 'created a new thought' for an everyday object, by signing a urinal and sending it in as his entry to an open art exhibition, he made visible the process of artistic thought, liberating artists for ever from the necessity to be makers of things. Since then, they have acted increasingly as assemblagists, illuminators of process, makers of connections between objects, people and their surroundings. The order they make visible is no longer the one-point perspective of the picture plane, shattered by the Cubist experiment of Picasso and Braque. They now reveal the ordering process of human society itself, ever-changing but always resurgent, revealed as moments of beauty and order in a chaotic universe. And the Utopian dream remains. In the words of Gilbert & George, masters of art as life, performers par excellence, 'Real art does not show or reflect life, but it can form our futures – a new world'.

Valuable Spaces

New Performance in the 1990s

Tim Etchells

In a public talk in Nottingham, not long ago, members of the Irish performance company desperate optimists spoke of a no-man's land at the edge of the streets where they grew up – a blackberry field where local kids would hang out and make mischief. It was to this place, as Jo and Christine Lawlor put it, that kids would go to find the unexpected, the dangerous and the almost inexplicable – a fire, a stripping or a stone-throwing fight. Jo said that in the blackberry field a kid called Dessie Ryan once pulled down someone's pants and whipped him soundly with stinging nettles. Hearing Jo describe it, you could not help but think that was one of those gigs where you really should have been.

I would guess that any childhood has a place just like that blackberry field: a dump, a show-house, a patch of wasteground, an empty factory; a place for breaking bottles, or impromptu helter-skelter rides; a place for the heating up of old fireworks to the point of explosion. Of course, when Jo and Christine talked about the blackberry field that night in Nottingham, they invoked its space – at once physical, social, cultural, psychic and imaginative – as a kind of junior equivalent to that of contemporary performance.

We go to performance, as artists, makers, audiences, producers and critics when we want the unexpected, the dark, the comic, the inexplicable. It's to performance we go when we want the borders between our daily lives and our imaginative lives to bend and blur a little, when we want to play out and challenge the orthodoxies, the rules and separations through which and in which we live.

It is no surprise that contemporary performance has a baffling diversity. We might expect contradiction in a space such as this. The artists one might cite as leading practitioners, or the organisations and producers with whom they work are often as different as one could possibly imagine, working in ways and in places that can scarcely be reconciled, to agendas that cannot readily be matched: performance in clubs, in galleries, in pubs, in gold-leafed nineteenth-century theatres, interventions in the stock exchange, works created for the Internet, for the streets, for saunas; artists coming from fine art, from poetry and storytelling, from theatre, from dance; artists using video and digital technologies, coming from outside art-training altogether; a crowded, contradictory space, written through with more histories than one could list.

Yet in all this contradiction there is a story to be dragged out of the mud, a story that has many versions, but one whose shape gets repeated and whose echoes can be seen in contemporary performance work across the UK, into mainland Europe, America and beyond. It is a story about limits and borders, borders and their erosion, about borders and the wars that take place over them; about the borders between areas of art-practice, and the testing of limits and borders between art-practice and daily life.

If one had to tell it in one sentence, one might call it a story of dissatisfaction. It was as if the old ways of making and doing, as if the boundaries of one's chosen form were for the moment, unbearable; as if communication rested upon finding new forms, new combinations of form, new contexts.

The 1980s and 1990s saw a continuation of the blurring between art forms and the exploration of new contexts for artworks begun in the 1960s. In these decades, the second and third generation descendants of immigrants have made their mark on British culture. At the same time, public space has been transformed by a strange combination of high-street video cameras and architectural kitsch, whilst the pervasive mass media – film, television, music, advertising, video – have continued to create a new visual literacy, a hybrid

culture that artists draw on relentlessly.

Mirroring changes in society, the Belgian choreographer Anna Theresa De Keersmaaker has moved from perfect, intimate and precise dance, such as *Rosas Dans Rosas* to works like *Stella* and *Achertland* in which theatre, video and a playful appropriation of popular culture sit side-by-side with a technical and vigorous classical dance. In the same period, UK-based director Pete Brooks (formerly of Impact Theatre Co-Operative) has shifted his theatre work into an ever closer relationship to film and film genre narrative – developing a language of projections and framings, cross-fades and jump cuts all achieved by theatrical means. The 1996 Turner Prize winner, Douglas Gordon, is a fine artist working in film and video installation, whose past work has included durational performance and the use of digital technology.

Erosion of boundaries between artforms is not an easy process, nor one without struggle or politics. When artists reject the formal orthodoxies of their training or medium, when they incorporate aspects of other forms in their work they do so most often from a need to communicate differently, to change the kind of experience they are offering up. Such redefinitions of a medium are not always smiled upon since, in departure from the beaten track there is always a critique of the old and a demand for new kinds of thinking, new types of attention from audiences, funders, critics.

Shot at close range in the arm by a friend and rushed from a gallery in Venice, California to hospital for his 1971 performance *Shoot*, the artist Chris Burden described those watching him that night not as an audience or as spectators, but as witnesses. It is a distinction which contemporary performance dwells on endlessly, since to witness an event is to be present at it in a fundamentally ethical way. To witness is to feel the weight of things and one's own place in them, even if that place is simply, for a moment, as an onlooker. The struggle to produce witnesses rather than spectators can be seen in excess/epic style at least, in the public piercings and mutilations by

American artists Ron Athey and Bob Flanagan or the 'suspensions' on meat-hooks carried out by Stelarc – events in which extreme versions of the body in pain, in sexual play and in shock, demand repeatedly of those watching – 'be here, be here, be here.' The struggle to produce witnesses can be seen in much milder work too and sometimes more clearly, in the rearrangements of audience space and contact repeatedly employed by the UK performance companies Reckless Sleepers and Blast Theory and in work by the

34

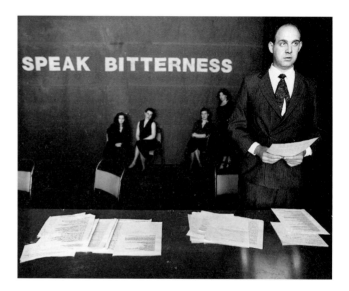

Forced Entertainment, *Speak Bitterness* (1995)
Photo: Hugo Glendinning

US group Goat Island, whose physical vocabulary (of school gym class, nervous ticks, sports moves and intimate gestures) is a type of witnessing, a writing of cultural biography in neglected physicality. The plea for witnesses is in the ritualistic slowness and simple presence of work by performance artist Alistair MacLennan, who charts a landscape half-public and politicised, half-private and resolutely interior. It is present in the durational performances of poet and artist Brian Catling, in the use of personal and unexpected public spaces by Bobby Baker and in the performance piece *Speak Bitterness* (Forced Entertainment, 1995) to light gently those watching. In this way the performers, whilst speaking the great litany of

confessions both real and imaginary that made up its text, could see the public easily and as individuals, not as a mass.

In each of these artists' work one gets, in different ways, an invitation to be here and be immediate, to feel exactly what it is to be in this place and this time. In *Speak Bitterness*, itself a textual form of bearing witness to the dreams and failings of a culture, the light on those watching meant, above all, that eye-contact was possible, so the two-way nature of every line was emphasised – something spoken, something heard – eye-contacts made and then broken again, eye contact offered, rejected, then offered again – a series of complex negotiations about complicity – about who has done what or who is implicated.

Twenty-six years after *Shoot*, the audience/witness distinction remains vital and provocative since it reminds us to ask again the questions about where art matters and where it leaves its mark – in the real world, or in some fictional one – and on whom it leaves its burden. The artwork that turns us into witnesses leaves us, above all, unable to stop thinking, talking and reporting what we have seen. We are left, like the people in Brecht's poem who have witnessed a road accident, still standing on the street corner discussing what happened, borne on by our responsibility to events.

Ron Vawter (1949-94), one of the New York theatre company, The Wooster Group's extraordinary makers and performers, once described their work as a question of 'replaying the tapes of the twentieth century, of going back over them to see what went wrong'. The group's work, in many cases built in response to documentary materials – source texts, video and audio tapes – could be seen as a strange kind of witnessing too, to the lives of the company (included as autobiographical fragments, as tiny shards and clues in the work) and to the history and culture which the group has lived through or dwelled upon. That this witnessing has taken place through the medium of quotation – through the recycling and re-combination of other forms, other artworks, exhausted strategies –

is in many ways typical of the current performance scene where the drive for new forms and new relations to spectators is always informed by a sense of history, by the developing strategies of the avant-garde, by the notion of popular culture as a reference book and image bank.

It has seemed that performance itself is both the memory and the chronicler of what might otherwise pass unrecorded or unnoticed in a broad public forum, an extraordinarily open space in which the connections between personal history and the broader sweeps of cultural life can be mapped and documented, a space in which identity itself can be kicked over, played with, reinvented. As adverse conditions – political, economic, medical – hit so-called minority or peripheral communities with increased vigour, the need for this space has grown.

The kind of semi-autobiographical witnessing (whether poeticised or straightforwardly narrative) practised by Mexican artist Guillermo Gomez-Pena and US artists like Annie Sprinkle, Karen Finley or Spalding Gray certainly has its equals in the UK. Drawing on personal and fictional materials, Black British artists like Keith Khan, Susan Lewis, Su Andi, or Ronald Fraser Munro have mapped British experience from their own particular perspectives, developing new forms of absurdist comedy, storytelling, performance and choreography to do so. Whilst Neil Bartlett, Robert Paccitti, The Handsome Foundation, Michael Atavar and others have created a politicised gay British performance that can deal both with history and with the present, mapping tough terrain, writing, as the late Derek Jarman put it, as witnesses in difficult times.

The slow but continual loosening of boundaries between artforms, evident since the 1960s, and with it a drive to make witnesses or participants not spectators has been accompanied by related attempts to make new contexts for the presentation of live work. This too has often been a highly politicised process. A decade or more of reactionary government in most of Europe and the US, the continual institutionalisation and museumification of art and cul-

desperate optimists,
The Showroom, London (1995)
Photo: courtesy The Showroom

ture, public funding crises and manufactured scandals over the fund-ing of supposedly controversial artworks have often led artists and audiences away from the centre-ground into more informal or unexpected contexts. Art in exile, or in hiding from the museum, has been springing up everywhere – in thriving art-clubs like Nosepaint and Beaconsfield in London, or the Quarter Club in Manchester, which have explored an energetic street-level mix between club culture, music and live performance bringing new artists and new audiences into contact with each other, creating unexpected results. Club-style events are perhaps more the natural environment for performers like the sound and language poet cris cheek or Ronnie Fraser Munro whose solo work stands some-where between stand-up comedy, Dadaist provocation at its most blunt and defiantly illiberal.

In thinking of new contexts artists have not only been considering the physical environment (not a gallery perhaps but a shopping cen-tre or library) – they have also been considering, in a broader sense the framework for consumption of their work. An ephemeral work, glimpsed by a passer by, a work of long-duration which cannot fea-sibly be seen as a whole by any single spectator, a work that sees its place, or its forum as being the global or national media space or the Internet, or the stock exchange – all of these are attempts by artists to position their works at the edges of the frame called art. Such new contexts are explored because, once again, the old meth-ods of delivery, the old contexts, the old relationships to the public, are no longer felt to be adequate.

Projects in the UK such as Bobby Baker's *Kitchen Show*, Platform's *Homeland* or Kirsten Lavers and Melanie Thompson's on-going *Zwillinge Project* all reinvent or question our understanding of every-day spaces through artistic intervention. Baker's next project *Jelly Game* takes the form of a game show for school children. In this she is making a move similar to that of performance artist Richard Layzell whose early 1980s performances in galleries using video and other technology gave way to street pieces and then to a series of

works presented in schools. Why, argues Layzell in his book *Live Art in Schools*, is something considered art when created for adults and not art at all when created for children?

A second blurring of context encompasses a range of organisations and projects dedicated to artistic intervention in parts of the landscape usually untouched by art. Perhaps the best known of these in the UK are Hull Time-Based Arts and Locus + (Newcastle) whose locations in the North of England point to the long history of radi-

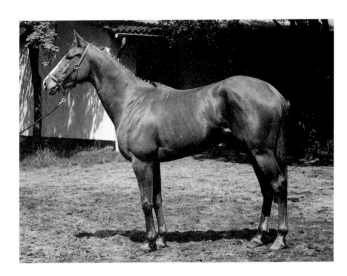

Mark Wallinger, *A Real Work of Art*, 1993
Photo: © Mark Wallinger, courtesy The Anthony Reynolds Gallery

cal performance work which has emerged away from the capital. Interventions by these two organisations, including the launch by Hull Time-Based Arts, of an imaginary company called UK PLC on the stock exchange, with all its attendant press-releases and media attention, serve to bring questions and artistic provocations to different people and to draw attention to the performative aspects of all social and economic interaction. In some ways, the launch of any company (or the management of any nation's self-image) is always a kind of performance. An event like the launch of UK PLC, or the purchase, naming, training and entry into races of artist Mark Wallinger's race-horse *A Real Work of Art* (raced, in suffragette colours of green, white and violet, during the 1994 flat season) also

40

serve to highlight the stratification of social space, the diverse ways in which events, objects and places are used and perceived by different people.

I am thinking back, not so much to the blackberry fields, as to the equivalent space of my own childhood – a steep illegal tip which was great for sleighing down, if you could just drag the bonnet of a crashed car to the top, push off and jump on board. The dump was a space in which new social relations were possible, one abandoned by the mainstream. It had some talented individuals and a ready supply of discarded materials with which to work – the rubbish, broken consumer items and half-burned tyres that make any decent performance. The dump was indeed a space, like desperate optimists' blackberry field, in which new things, or new combinations of existing things were possible. It was a space for activities which could not be done elsewhere, in the real world which was carefully screened off by dark trees. Above all the dump was a magical space whose contents – fights, actions, dares, boredoms – continued to have consequences in the world beyond its borders: changing things, changing everyone that went there, making participants and witnesses, just like performance at its best.

The Eros of Rose
The Work of **Rose English**
Deborah Levy

Just when everyone was announcing that the soul had gone out of
fashion and, in mournful postmodern tones, proclaimed the 'Death
of Wonder', Rose English strode on to the stage, six feet tall, prob-
ably costumed in the longest eyelashes in town, and returned those
troubled subjects to us. A tremendous physical presence to behold,
she understands that the empty conceptual space of the theatre
can be a place where we are caught in the adventure of 'looking at
the mystery of looking'.

In a Rose English show, every gesture, every object and every
image is part of her metaphysical narrative. Whether it be a sugar
lump, a live stallion or a glass wand, the stage resonates with the
fullness of their presence. She makes for herself on stage, a visual
and kinetic world that is curious and pleasing, a world made up of
moments which could go any way. This of course might just be the
deception of a skilled performer, but she creates a chaos of possi-
bilities through which she pulls her enquiry with charismatic com-
mand and wit. Rose English wants to ravish her audience.

It is rare to feel thrilled that somehow, against all the odds, a cul-
ture, a country, a time and a place managed to drag up an artist
who not only acknowledges her debt to Tommy Cooper – whom
she has described as 'the Marcel Duchamp of music hall' – but who,
in later work, has attempted to forge a relationship between popu-
lar forms and the avant-garde. Both of these she believes 'have pro-
found truths in them'. Who else could create a whole show based
around the question 'What is it that makes a form?' and have the

audience rolling in the aisles begging for more?

English's Fine Art training at Leeds Polytechnic in the early 1970s coincided with an energised period of experimentation and cross-fertilisation of art forms: revue, poetry, sculpture, cinema, dance and the experimental novel. These influences were not subsumed into the conventions of theatre, but became the basis for innovative forms that would come to be called 'performance art', and later 'live art'. A maker of exquisite objects, Rose English might have

42

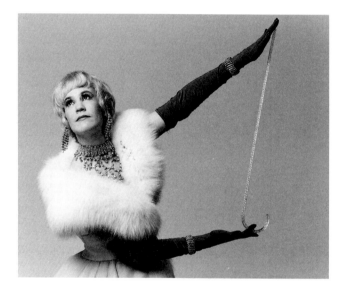

The Double Wedding presented in collaboration with LIFT'91 at the Royal Court Theatre, London (1991)
Photo: Hugo Glendinning

been talking about herself when she has a character say in her 1991 show *The Double Wedding*, 'He is in love with the image. He was born in its thrall.'

Early performances included a happening in Nottingham forest, in which she placed a goose inside an elaborate Victorian cradle and surrounded it with small white porcelain stallions. An image of this fairy tale voodoo, made to be found in a forest glade by the picnicking public, can now be found in volume one of Jeff Nuttall's book *Performance Art Memoirs*. Horses appear again in *Quadrille* an early work for a show jumping event in Southampton. English persuaded the organisers to let her choreograph six women dancers who

wore hooves strapped to their feet and small horse tails pinned to their behinds. It was a both a formal and lighthearted intervention: English confesses that an army childhood spent marvelling at the Royal Tournament made it very difficult to choreograph anything that is not symmetrical. From miniature porcelain horses and human simulation of horses, Rose English, twenty years later, would appear centre stage at the Queen Elizabeth Hall (having just trans-ferred from Broadway) with a live performing stallion.

English has said that it was when she was invited to make an entrance with a horse as a feathered and sequined personification of champagne in the English National Opera's production of *Die Fledermaus*, that she realised she had a particular affinity with the horse as an 'animal showgirl', a relationship English would work with in later shows. In early shows, however, the personae she played with were more austere. These were the days before the 'Mistress of the Monologue' found her speaking voice and indeed a voice teacher – the famous Patsy Rodenburg – whom she cheekily asked to help her speak like John Gielgud. Rodenburg must have had other plans in mind, although it might have given British culture a whole new industry to export: Sir John impersonators, intoning 'Listen to those sequins crumble as I sit'.

Many of English's early performances were created with dancer Jacky Lansley and film-maker Sally Potter, with whom English co-wrote and designed the cult film *The Gold Diggers*. Its exquisite visu-al menu was, in a way, preceded by shows like *Park Cafeteria*, 1974, in the Serpentine Gallery. This was a time when artists were invited by curators and arts programmers to make performances quickly for a specific site. The performances were improvised, fun, immediate. *Park Cafeteria* included Jacky Lansley shooting at dogs in the park from the roof of the Serpentine Gallery and then taking pot shots at English as she came whizzing down the path on roller skates, a pair of swan's wings strapped to her back. It was an opportunity to play with cinematic images, using music and light to structure an impro-vised theme, as in a later show, *Rabies*, made for The Roundhouse in

London. Famously performed in the heatwave of 1976, the most memorable image in *Rabies* was the naked English, donning a fur coat and howling in front of a cinema screen.

One of English's all-time favourites was the epic *Berlin*, also devised in collaboration with Sally Potter. At the time they were living in a large Regency house, a squat in Mornington Crescent, and, frustrated with making shows in art spaces, they decided to make *Berlin* elsewhere. It would start and end in the house itself, while the second and third parts would take place at the Sobell ice rink and at Swiss Cottage swimming-pool. Sally and Rose began to think about 'the notion of dynasties, the male child and The Fall, using men as a chorus instead of the central protagonists, communion, nourishment and miracles'. Images would include a cradle bursting into flames on the ice, two women swimming naked in the pool whilst continuing an argument, and the male chorus dressed in nineteenth-century costumes, feeding bread to a six-year-old boy. As well as making her own solo shows, many of which were produced for galleries and museums, English went on to perform and design for some of Britain's most prominent experimental theatre companies and directors, including Lumière and Son, Tim Albery and, later on, Richard Jones.

It was not until 1983, however, that 'the Eros and wonder of the theatre space' begins to appeal to English. 'Its emptiness is a potentially wonderful and marvellous thing,' she muses. 'Space has its own aura of potential or lack of potential which is deeply thrilling. Theatres often have a depressed pall about them. What is it that falls over everything that happens there? The atoms just go to sleep and they don't come alive until someone tickles them to life again.' For a performer like English, the space is her show – which can be a rather difficult concept to sell to someone.

In *Plato's Chair*, premiered in Toronto to great acclaim in 1982, English as ever, uses the space as a performer with whom she interacts, interrogates, and rearranges. At its première at the Drill Hall in London 1983, English set up a small stage in the bar to ruminate

on the large subjects of death and the soul – ironically using the spacious auditorium adjacent to the bar as her dressing-room. It is from the auditorium that she returns carrying two tall, mock plaster pillars which she uses to frame the smaller void of her makeshift stage. It is English's contention that 'form reveals the soul of things', and members of the audience are called upon to evaluate what it is they are seeing and experiencing – whether it be a prepared dance executed with a knowing mixture of grace and amateurism, or a woman weeping out loud while she laments not being able to sing. English often sets herself and the audience an unsolved dilemma, presenting herself as a fallible wanderer on a quest. In this sense every show is an adventure, a blind date with a great improviser, who often seems as surprised at how something turns out, as is her audience. The Eros of Rose is that she is an artist who can make every moment as exciting as it can possibly be.

Plato's Chair was followed two years later by *The Beloved* and, produced by Luke Dixon, was performed both in galleries and theatres in London and Vienna. Its starting-point, English confesses, was that she genuinely could not remember the true meaning of the word abstract: 'It is much more profound and complex than "non-figurative" or "non-representational".' In *The Beloved*, she played with the theatrical tradition of 'the set', or 'the entrance', using an assistant for the first time in a role that was minimal, but broke the pattern of solo performances. It also gave the audience, and herself, someone else to refer to. The humour, mostly verbal, is suddenly punctured by the donning of a kit-e-kat mask or by eating a large slice of chocolate cake before performing a ballet routine in a too small tutu – as if to mock the solemnity with which we are taught to regard these traditions.

The Beloved revealed English's ability to keep the audience within sight at every moment, and to insert them into the text with integrity and dignity, even when she is berating them. An interesting project for a female performer is to make a decision about what kind of attention she wants from an audience. English manipulates

our gaze in an intriguing way because she too is a spectator in her own show, looking with us, rather than being gazed upon. This decision to focus, or reposition the gaze, has echoes in the work of other female visual artists: Helen Chadwick, Mona Hatoum and Cindy Sherman, for example. When Sherman turns the lens on herself, the kind of attention she asks of the spectator is almost always playful, droll and reflective. Her multiple personae, like those of English, allow her to present to her audience a world in which doubt and loss co-exist with the stuff of our best dreams. The effect is a bit like the safety warning on a box of matches – 'Strike softly away from the body'.

The dreamer in English is always imbued with irony, whether it be gentle or mocking. Duchamp has written that 'irony is a playful way of accepting something', and for English the 'something' seems to be the gap between the splendour of the dream (a place in which we can 'reveal the density of our desires') and the fallible dreamer who watches her vision reduced to dust before her, and the audience's, very eyes. Her next two shows *Thee Thy Thou Thine*, which premiered at the ICA and then transferred to The Bloomsbury Theatre, London in 1986 and *Moses*, performed at The Drill Hall in 1987 animate the hilarity and tragedy of this gap.

For someone whose roots are in the avant-garde, and who was amazed to discover 'that acting is basically lying', the next nine years in English's corpus heralds a great blossoming of large-scale work in theatre spaces in the UK, North America, Asia and Europe. She was also invited to work with film director Nic Roeg. Perhaps the most significant change, though, is that she began to script her shows for large casts, as well as directing and performing in them. The interesting conundrum here was that the 1980s were a difficult decade in which to make such innovative work in the UK. The era marks the demise of a number of leading experimental theatre companies, and also a distrust for contemplative, problematic work. Of this time, Rose says, 'An extremely humble event would make my heart fill with hope. Anything that was the antithesis of the rather grandiose

gestures that were around at the time, and that had a modest insistence on their own goodness.'

It was the 'intransigence of this climate' that in a large part formed English's 1988 spectacle *Walks on Water*. It also coincided with Rose and designer Simon Vincenzi visiting the Lido and the Folies Bergères in Paris. English was interested in this tourist icon because 'It was charming, tawdry and funny. There were these men dancing around in yellow shorts playing mock concertinas and no one was

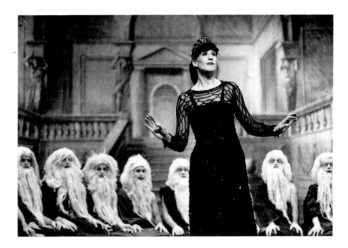

Walks On Water, Hackney Empire, London (1988)
Photo: Mike Laye

laughing! The audience had forgotten this was a folie! Tears were rolling down my cheeks.' One act that caught her attention involved a woman merely presenting her costume. 'A huge drape was placed on her shoulders and once she had walked in it down a large flight of stairs – the curtain came down! Someone had the good sense to realise that this was the only good moment in the whole scene.'

The spirit of the Folies is very much present in *Walks on Water*, performed at the Hackney Empire, an opulent old variety palace designed by theatre architect Frank Matcham. English decided to make a large-scale collaborative show that would refer to the glorious vaudeville traditions of the venue, if not entirely in keeping with them. She massed a cast of twenty-eight, including a dancing male chorus of twelve, a children's ballet, a stunt woman, massive

scenery, flying devices and a waterfall. The persona of earlier shows, *Plato's Chair*, for example, in which she was rather stern, had now given way to full-blown showgirl bravado.

The fun in the costumes worn at the Folies had been contagious: 'there was a lot of good humour around those outfits and much complicated manoeuvring to get away with them'. English was interested in the juxtaposition of wearing the kind of vaudeville outfit once worn by people who did not speak: magicians' assistants or dancers who would just pose and parade in an ironic fashion. English found the outfit was charged with a level of entertainment itself: a vast, yellow-feathered head-dress, diamanté bra, G-string and elaborate body drapes, fishnets and long yellow gloves. The title *Walks On Water*, a stunt she actually performs in the show in a pair of stiletto silver sandals, came, in part, from football songs. It seemed to English that a way of dealing with bleak times was to create something wildly joyous.

Walks On Water is set in three metaphorical worlds. The first is architectural and classical in which the twelve men become a mock Greek chorus in curly white wigs and beards. In the second part they become a forest dressed as trees. An 'ill wind' is blowing and their survival strategy is to lean into the wind. The third is an ingeniously constructed waterfall in which they become formation swimmers in a hilarious parody of Busby Berkeley musicals. If Duchamp's alter ego was Rrose Sélavy, a pun on Eros C'est la Vie, a character taken from a poem by Guillaume Apollinaire. Rose English has an acrobatic alter ego, a body double who jumps through six burning hoops of fire on her behalf. The suggestion is that we are capable of reimagining ourselves, despite the ill wind that breaks our spirit and bravado. Even the sombre chorus of patriarchs is redescribed when each are given one baby daughter to hold. English uses this space, 'a domain that is the epitome of illusion and artifice' to explore invincibility, as the title suggests. Courage is always a tender action to behold – it implies we are going to attempt something we never believed ourselves capable of. But it has another side too.

It is a little bit ridiculous. English knows this, and attempts all kinds of stunts that fail hopelessly.

She will repeat her relish for puncturing the possibility of perfection in her next spectacle, *The Double Wedding*, presented at the Royal Court Theatre in 1991. 'Why can a form catch on and endure for thousands of years and why is another more fallible? What happens when one form falls in love with another? Cinema and theatre for example.' English confesses that the same old subjects exert their fascination over and over again, 'I keep going back to the void hoping people won't notice. It's just THE topic really.' Always on the look out for an opportunity to send up such ethereal preoccupations, English has a minor character bitch behind her back, 'Such a hypocrite. She pretends to find the popular inspiring but I know she slopes off to the most esoteric events for true sustenance.'

Nevertheless English imports a small ice rink into the auditorium, complete with world famous skaters, aerialists, and a cast whom she names in her script as The Hypnotists, The Camera Men, The Viscera and The Figment. All of them have had some part to play in the past production, *The Double Wedding*: 'I remember the first night/ The costumes still felt stiff/We were enthralled'. As ever she presents herself at the centre of the spectacle and in the best costume, in this case, a shimmering Dietrichesque sequined dress that explodes into a froth of gauze at the knee. 'Yes, I know what you are thinking! How is a woman wearing a dress like that going to sit down? Such tension, don't you think? Just listen to those sequins crumble as I sit. Never before in a show has a sequin had to represent so much and so little at the same time!'

Holding a glass wand in her red satin gloved fingers, a tool to chase her story, for she is both a 'hostess and a hermit', English attempts to hypnotise her assembled dramatis personae. Two characters called The Dew and The Dawn, dressed in red wigs, stop in the middle of a paltry *pas de deux* and acknowledge that they are just not very good dancers. Harry and Otto, the cameramen, discuss the pros and cons of realism as seen through the lens, while the

49

50

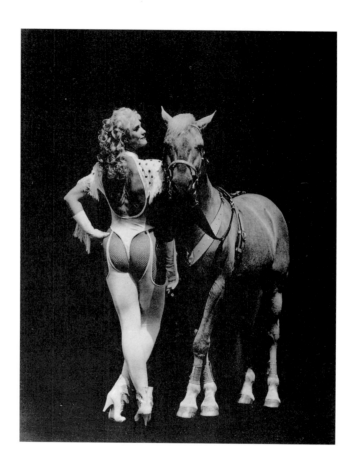

My Mathematics presented by
Cultural Industry at the Serious Fun
Festival, New York, Queen Elizabeth
Hall, Brighton Festival, Sadler's Wells,
Adelaide and Sydney Festivals (1992-3)
Photo: Gavin Evans

Tantamount Espérance presented by
Barclays New Stages Festival at the
Royal Court Theatre, London and

Contact Theatre, Manchester (1993)
Photo: Hugo Glendinning

hypnotists fight for the left-hand side of the stage. At one point, the whole cast appears dressed as clones of Rose English herself, who chastises them for so badly enacting her when this is 'the age of the hyper real'. This show with its dazzling abundance of beauty, begins and ends with a question: 'What is the difference between a vacuum and a void? One is only empty/the other is a deficit of emptiness/the one is open and infinite/the other is hermetic and closed.'

English's finest, if most desolate and obtuse persona to date, is that of the philosopher and magician *Tantamount Espérance*. A sequel to *The Double Wedding*, *Tantamount Espérance* was again written, performed and directed by English, and presented at the Royal Court Theatre in 1993. The credits on the programme give an idea of how English uses and subverts the popular forms of magic and music hall to 'reveal the secrets of the soul'. In addition to Ian Hill's thrilling and melancholic music played by a Tango Trio, there is a flying consultant, an illusions consultant, a magic and tango consultant. All of them conspire with Tantamount to help him consider the future: 'What is this fever? What is this time?'

English interprets this male persona as a cerebral aesthete, a dash of wise silver in his well-coiffured hair. He wrings his hands whilst three musicians warm up against a shimmering curve of curtain – a twilight zone designed with genius once again by long time collaborator, Simon Vincenzi. Tantamount speaks his troubled heart directly to the audience, 'I have been waging a personal war on nostalgia...on what I perceive to be an inability to embrace an idea of a future....what has happened to our sense of eternity?'

As Tantamount's spiritual mentor walks through the air strung up on wires, the enigmatic Imogen Grave, a film noirish nocturnal vision in a low-backed ballgown, meditates on the nature of ethics. She is Tantamount's muse and subject of his tortured gaze: 'the soul sometimes wrestles with a dilemma. It is confronted by a truth about itself which it has to decipher so that it is not diminished.'

English's male persona is a heroic tragic figure – she has described stepping into his shoes as being like 'playing King Lear'. Tantamount

excites desire but ultimately keeps out of reach. When he is at his most abstract, an aerialist spins dizzily through the space, or a conjuror produces glasses of milk from nowhere – stunts composed to support and deepen English's verbal metaphors. This is how English brings together the ruptured moments of her show, in the same way a great orator finally harnesses the fractured sum of her argument.

Perhaps it was a relief then, to return to a solo performance in *My Mathematics*, which was developed alongside *The Double Wedding* and *Tantamount Espérance*. English introduced the persona of 'Rosita Clavel', a showgirl from a bygone era – and her last remaining horse – to massive audiences at the Queen Elizabeth Hall, London and the Lincoln Center, New York. It is in this disguise that English addresses some of the themes of the evening. 'Is O a number? What is beauty? What does the gap between bafflement and understanding, tragedy and joy, pleasure and pain add up to?' Fluttering her three-feet eyelashes (the inspiration for which English got from her sister's sluttish dolls), she invites an audience member to come and be butterfly kissed. No partakers of 'the affectionate gesture' then? Yes. Someone obliges. And how about a volunteer to be 'lashed' with the very same eyelashes? Both kiss and lashing are performed in the same moment while Rosita, hands on hips, meditates on the gap between pleasure and pain. The second half introduces the horse, whose name is the title of the show, *My Mathematics*. His mistress points out the similarities of their bare backs (Rosita's buttocks are brazenly revealed via a G-string rhinestoned cowgirl outfit) and another similarity, they both love applause! This beautiful golden stallion stands on the sand-strewn stage. Behind him, a white screen slowly fills with the bluest of cinema skies. The horse even rises up on two legs and rolls in the dust like in all the best movies. 'My beloved,' Rosita coos when he nuzzles up against her, 'You're looking for snacks. I know you are. Aren't we all?'

Never/As Simple as ABC
The Work of **Gary Stevens**
Yve Lomax

2

Gary Stevens is a proper name, yet how are you to name his prac-
tice? Would you speak of a fine-art practice? Would you speak of a
practice of theatre? Would you speak of performance art? Would
you speak of the extended field of sculpture? Of course, any reply
given would depend upon what you thought these terms, these
names, were designating.

You are taught to say A is for Apple, but naming is never a straight-
forward matter. Never as simple as ABC.

It could be said that, since the early 1980s, Gary Stevens has been
responsible for the production of a series of works which involve:
Gary Stevens himself and others, as performers; rehearsal and
choreography; durations of sixty to eighty minutes; a variety of
venues from art galleries and theatres to town halls and television
studios; humour; connections with Buster Keaton, duo acts such as
Laurel and Hardy, the odd character from a Samuel Beckett play, or
indeed a Robert Wilson production; games, fuzzy logics and, at
times, technologies which afford experimentation with sound and
so-called 'techno-cultures'.

Yes, you could attempt to produce a list in the hope that this will
provide enough examples to enable you to know what Gary
Stevens's practice is made of and, thus, to name it. But, again I put it
to you, naming is never as simple as ABC.

To be sure, the works which Gary Stevens is responsible for do
have proper names. Here are a few: *Invisible Work, If the Cap Fits,
Different Ghosts, Animal, Audience, Simple, Name, Time Piece, Stuff,*

Sampler, And.... Perhaps you can tell a lot from these names, but do they tell you how to name a practice which, in itself, continually makes the process of naming a precarious activity, something which is thrown up in the air?

> What do you call this aggregate of peculiar characteristics?
>
> Do they have a name?
>
> No, we didn't give them a name.
>
> *Animal*, 1989

Yes, this is what Gary Stevens's practice does: with all the humour of a stand-up comic and all the seriousness of a challenging philosophical thinker, he makes you question the very act of naming.

What is more, by continually producing reversals, making the philosopher funny and the comedian seriously unfunny, Gary Stevens comes to question the act, and indeed the culture, which names not only the philosopher, the comedian but also the human, the animal, the artist. Not only this way, but also the reverse way. Yes, with Gary Stevens's practice you constantly find things going in two ways at the same time. Things never proceed in a manner as simple as ABC. Yes, it is Gary Stevens's practice to invert hypothetical assurances such as A always proceeds B.

Are you, then, to call Gary Stevens a traitor?

A traitor, yes, to the established order of names. A traitor but never a trickster. There are many times when Shakespeare puts on stage a king who comes to the throne by trickery, yet with Gary Stevens you find no such Shakespearean stage, no staging of trickery, even if you see the well-worn trick of stumbling over a carpet. A trickster aims to take possession of fixed properties, such as someone's crown. But Gary Stevens betrays the very idea of a fixed property which can be possessed. He betrays the idea that something, which includes both theatre and fine art, possesses fixed properties or characteristics which determine the speaking of its name.

What does this betrayal of a world of fixed properties produce?

It produces something fresh; it produces processes which are *coming about*. A philosopher might say, *becomings*.

In a split second you find yourself moving from a world comprised of fixed properties to a world which is set in motion, a world which is in the process of making itself, emerging, dissolving, coming about.

Then, a carpet ceases to have fixed properties but becomes what can only be called an event.

> I don't know if tripping on the carpet is strictly part of his routine or if he forgets that it's there every time. He got the chair before we had the carpet, you see.
>
> *Animal*, 1989

Let me put it to you that Gary Stevens's betrayal produces something special: events, pure events.

Suddenly, a philosopher's ears prick up whilst someone from the audience shouts out: *What is an event?*

An event does not just mean that 'a women has been run over'. I cannot pretend to have the last word on the matter, but let me say an event is the process of something coming about.

The philosopher might say: 'An event is a temporal modulation of the continuous variation of a world in the process of making itself'; to which you may respond: 'In other words, an event is that which is always and already en route'.

In *Simple*, performed for Heatwave at the Serpentine Gallery in 1990, Gary Stevens spends all his time attempting to prevent cups and saucers from smashing to the art gallery floor. Cups and saucers cease to have a fixed place (as when a table is laid for afternoon tea); they are endlessly *en route*, in the process of coming about. It is a very delicate matter, yet the humour makes you yourself modulate and fold up with laughter.

You may think an event is what happens when, in a split second, a cup is dropped and smashes to the floor. You may think an event is a rupture in the course of things. Yes, you may think that events are those dramatic moments which change the course of history. However, the philosopher puts it to you: 'Making an event – how-

ever small – is the most delicate thing in the world: the opposite of making a drama or making a story'.[1]

Even when everything appears to be up in the air (as it does so very often in Gary Stevens's productions), even when nothing whatsoever appears to happening (least of all a plot or a narrative), the making of an event is quietly, and delicately, taking place.

It is, dare I say, a philosophical matter.

Let me say that being *en route* or *coming about* entails that something

57

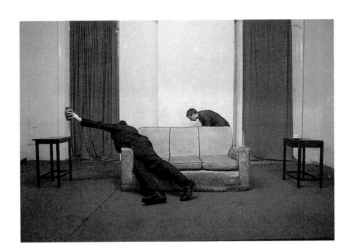

Invisible Work (1984-6)

In a verbal tit-for-tat routine performers impose psychological conditions on one another. They explore and develop those conditions and imagine the consequences. They test their stories to breaking point. The simple staging is in contrast to the complex imaginary situation.

or somebody is becoming-other. The philosopher suggests: 'It's like becoming a stranger to oneself, to one's language, to one's nations'.[2] However, and this must be stressed, this is not about an alienation where becoming-other entails a loss which effectively halts you in your steps, or immobilises the movement of your spirit. You are not immobilised, as if turned to stone, by the loss of something. Becoming-other, you are already becoming something else. It is, what you could call, a life.

(The poet Lucretius tells me that there is nothing on this earth which does not have a porous existence. Stones let water in; they become filled with water and this fluidity makes a stone a process (albeit a very slow one) which is *en route*, a process of becoming-other. Stones: let's say that they are events too.)

Events, in their process of coming about and becoming other, always bring with them something which you might call alien. Gary Stevens makes events of a carpet, of cups and saucers, a face, a word or sentence, a human body (with or without clothing), and, yes, you can speak of these processes producing aliens. Yet these events, these processes of coming about, these aliens will never produce an alienation which petrifies you. To be sure, they can make you think in the manner which Bertolt Brecht's 'alienation effect' wishes you to think critically, but these events will never turn your soul into a non-porous unmoving matter. A sad soul, in other words. On the contrary, your soul will quietly vibrate. Yes, that is what temporal modulations can do: vibrate the soul and make it sparkle.

It is, dare I say, an ethical matter.

Being *en route*, becoming other than you are, means that there is never just one thing involved. There is always and, and, and. Partaking of events means you are always repeating the word 'and'; it's like stammering. The philosopher Gilles Deleuze reminds me that this stammering produces the effect of being a foreigner in one's own language. In 1997 Gary Stevens creates, at the South London Gallery, a production named *And...*. During this 'performance for ten people' you do not hear the word 'and' repeated and repeated, yet the stammering effect is there, forcefully at work. The 'and...' may be inaudible but listen carefully whenever you see something becoming repeated, and repeated, and repeated.

It is, dare I say, a matter of time.

I have spoken of temporal modulations. Yes, with the making of an event there is a modulation of time itself, an inflection which stretches the idea of measurable, clock-wise, time.

The becoming of an event is never a straightforward matter; on the contrary; it is always going in two directions at once. There is, at the same time, the *having already happened* and the *still to come*. The present as such comes to elude you and the very idea of an instant or

split second cannot quite be grasped. Let me spell it out: the double-act of *what has happened* and *what is going to happen* is what paradoxically constitutes the event.

In *If the Cap Fits* a double-act is at work. Part of this double-act consists of two bodies becoming larger AND larger. Now, in terms as simple as ABC, you could say that what is happening is that two human bodies are putting on more and more clothes and becoming larger. But wait, you may come to miss the event of getting larger.

59

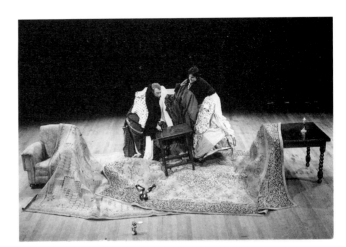

If The Cap Fits (1985-7)

The performers are continually putting on clothes. Their appearance becomes strange, both infantile and geriatric with the heaping up of clothing. Exposure and vulnerability are dealt with by the compulsion to cover up.
Photo: Georgina Carless

And what does happen with the event of becoming larger?

What happens never proceeds in a straightforward manner, as simple as ABC. Indeed, things go in two directions at the same time: getting larger you also get smaller. The reverse is always happening at the same time.

Let me explain, if only for myself. With the becoming of the event (of getting larger), the present eludes us and we can never come to rest upon a fixed point. So, getting larger, as with becoming more, never stops where it is but always goes further. Becoming larger is always becoming *more* larger and *less* smaller; and, equally, becoming more smaller is always becoming *more* smaller and *less* larger. A consequence of this double-act (of the less and the more) is that the larger can become smaller (less) than the smaller and the small-

er become larger (more) than the larger. In short, the more can become less than the more.

As I have said before, with Gary Stevens's practice you continually find the production of reversals. It is this production which invites you not to miss the becoming of the event.

But wait, something here must be stressed. Becoming larger and becoming smaller never finally become so; *if they did they would no longer be becoming, but would be so.*

It is not so easy to think in terms of the becoming of the event (especially so, since then thought itself becomes an event). Yes, thinking in terms of the becoming of an event is stretching my thought. Yes, Gary Stevens's practice is bending my thought.

In one sense you can say that Gary Stevens's practice is never as simple as ABC; yet in another sense, it is always as simple as ABC – kids' stuff, as the saying goes. Yes, you can say this, for Gary Stevens's practice (which does indeed do stuff for kids) is always moving in both senses or directions at the same time. You might say: both sense and non-sense.

What must be stressed is that 'what is in the process of coming about is more what ends than what begins' Events do not happen between two instances. I put it to you: events are endless.

That events move between the 'still to come' and the 'already happened' makes the time of an event indefinite. Yes, something wonderful happens to that conception of time we call 'Chronos', the measured time which ticks and tocks and divides our day into a number of seconds. Simply put, it warps and bends and stretches. Time stretches and then you find yourself partaking of indefinite time. A time which can be called 'Aeon'. Some would call it paradise. Time becomes limitless, and so too does thought. With events something happens that reason has *not yet* known. With this sort of thinking, one accepts the event for what it is: the *unthought within thought.* You can call it nonsense if you wish, but thought has no life without it. A process of thinking which is a thinking not already

thought: is this not what the philosopher strives for? Is this not the joy which Gary Stevens is bringing to me? The joy of having to think. Events have no beginning or end (even though a duration of seventy-three minutes may be involved, or indeed a split second). An event is, in itself, pure becoming. *En route*, in itself, has no beginning or end. In itself, it is absolute middle. At the beginning of one of Gary Stevens's productions, you have the feeling you have entered something that is already *en route* and at the end you have the feel-

Different Ghosts (1987-8)

Period costumes are utilised like team colours. The performers operate together and overlap in different imaginary interiors. A game is played where the performers acknowledge only those dressed in costumes from an earlier period. The 'earliest' character is isolated and disruptive, she ignores everybody on stage, while the latest is, in effect, invisible.
Photo: Corinne Turner

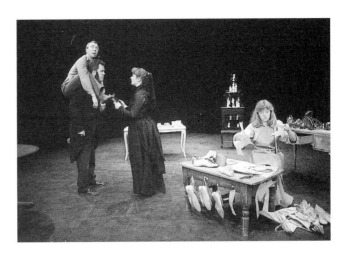

ing you are leaving something in the middle. Unresolved, you might say. The plot is that everything begins in the middle and everything ends in the middle. This is what makes Gary Stevens a traitor to the plot, the drama, the story.

Why be disappointed when something starts in a fluid state and ends in a fluid state?

> And then from the audience an inquiring voice makes itself heard: 'perhaps it is a matter of fluid state physics?'

The thought is not so absurd: there is a connection to be found between Gary Stevens's productions and the science of fluid states. Fluid state physics is far more concerned with the fluctuations, turbulence and variability of processes coming about than with axiomatics which seek to take possession of fixed properties and principles.

The thought is not absurd: Gary Stevens's work can be connected to Lucretius's poem *De Rerum Natura*. The contemporary philosopher Michel Serres contends that this poem, written in the century before the birth of Jesus Christ, is a valid treatise in fluid state physics. He claims that the poem itself produces the flux which marks the becoming of events. How can the poem not be of interest to the scientist seeking to understand the events of a world in the process of coming about? However, it would be absurd to suggest that Gary Stevens's productions resemble Lucretius's poem. It is not by resemblance that a connection can be made, rather it is more to do with two productions being in sympathy with each other.

Why do we spend so much time seeking connections by way of resemblance?

A traitor but also a teacher. Perhaps like Lucretius, Gary Stevens can teach us something about fluid state physics. A traitor but also a teacher, again a double-act is at work.

'I am writing.' At school I was taught that this simple sentence consists of a subject and a predicate. The subject precedes the predicate as A precedes B. I was taught that the predicate is an attribute of, attributable to, the subject. Thus, when I write 'I am writing' the writing is to be attributed to the subject 'I'. In the same manner, when I write 'The tree is green', the green – the predicate – is to be attributed to the subject 'tree'. Yes, at school I was taught the lesson that the predicate is the property of the subject.

> But wait, the becoming of the event, which Gary Stevens's practice is bidding me to think and write of, betrays this lesson taught to me as simple as ABC.

Let me be bold in my writing: Gary Stevens betrays, is a traitor to, the lesson I was taught at school. For what do I learn, indeed what am I learning, as I study the practice of Gary Stevens? I am learning that the predicate is a an event. The predicate is the execution of writing (of learning, of greening); it is an act, a movement, a change

and not a state of this I or the subject-tree.

Let me put it to you: Gary Stevens teaches you that learning is an event. The pure act of learning remains unattributable to a subject. Here is the lesson you find taught: the event, properly so-called, betrays attribution. The predicate is above all an event and not an attribute of, nor attributable to, the subject. However, and this must be stressed, Gary Stevens is not a murderer. He does not kill off the subject. He does not make a spectacle by way of a killing. In ways

63

Animal (1989-90)

An island of toys. The performers enact behaviour reminiscent of certain animals. They may appear obedient, uninhibited in their affections, over-excited by someone's entrance and devastated when they leave. However, they have little or no power of recognition, avoid eye contact and have no use for facial expression.
Photo: Sheila Burnett

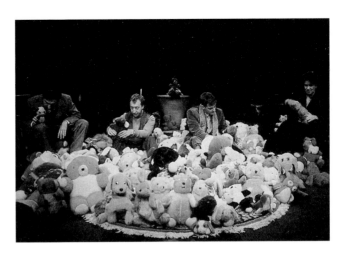

which are remarkably unspectacular, as ordinary and everyday as making a cup of tea, he transforms the subject itself into an event.

Here then is the lesson: not the tree is green but the tree greens. And here something special is happening: the verb is passing into the infinitive – to green, to learn, to write, to speak. Verbs in the infinitive are, as the philosopher would say, 'becoming'; there is a coming about of greening, of learning, of speaking, of writing. Verbs in the infinitive have no subject, they refer only to an 'it' of the event. It is raining. It is speaking. It is learning. It is writing.

In *Animal*, five people are involved in the act of writing a letter. One sits at a table upon which is a sheet of paper. Two are crouching on either side of this one and a pen is held by one of these two. Standing behind these three are another two. Exactly who, or what,

**A Split
Second of
Paradise**

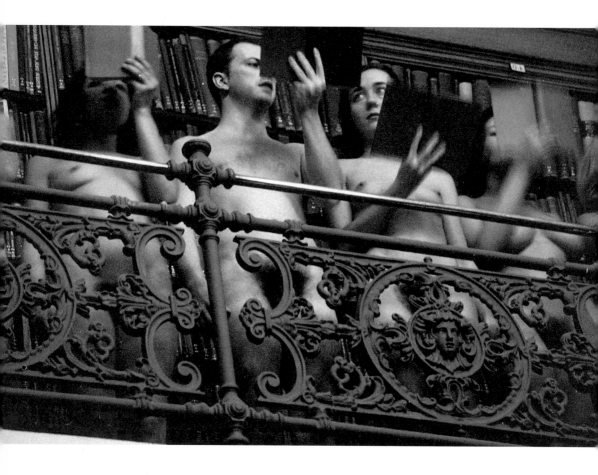

Time Piece National Art Library,
Victoria and Albert Museum (1993)

When the bell chimes, ten naked
performers appear on the balcony of
the library. Like the mechanical fig-
ures on an astrological clock, they
perform a sequence of orchestrated
movements. First they raise and then
lower books that reveal and conceal
their faces, next they mutter and then
they glance at one another in silence.
Photo: Jeremy Ackerman

is writing the letter? The one in the middle appears to be writing the letter but this one is not holding the pen. The pen, which is doing the writing, is held by one of two on the side. Not a word of the content of the letter is spoken between the one in the middle and the two on the side yet the letter is being written. And what of the two behind the three? To whom is the letter attributable? The 'it' of the event.

This is what I am learning: the more I see of Gary Stevens's practice the more I learn that this practice, by a variety of means, is continually throwing up in the air the question of attribution.

Take any one of Gary Stevens's performances. Listen to when something is said and then ask: to whom is this utterance attributable? Time and time again you will find that the utterance remains unattributable to the subject of enunciation – be that of the character-actor or indeed the performer-artist.

There are so many examples I could give where Gary Stevens teaches us that events are not attributable to a subject. In *Animal*, it is the event of an inexpressive face. In *Stuff*, it is a synthesised voice. In *Name*, it is a posture. In *Sampler*, it is an audio world where the subject itself becomes the event of a sound. When we cease to attribute the predicate to the subject, a person becomes an event ... an atmosphere, a fog, a wind, a heat.

I speak of a traitor but not a murderer. Michel Serres reminds us that nothing excites like death. 'Make no mistake – the first spectacle is murder.'[3] At the origin of the spectacle is murder. Make no mistake, the first theatre is founded upon the spectacle of murder. Gary Stevens does not create a spectacle. You will never watch a murder. Gary Stevens is a traitor to 'the theatre', yet he never performs a killing. He does not kill off the theatre, he transforms it. He turns 'it' (including the audience) into an event.

The making of an event is a delicate matter, requiring prudence, experimentation and practice. (Yes, the making of an event can require rehearsal.) Gary Stevens devises all sorts of rules, games and logics to perform these requirements; yet, there is another

requirement which he performs: *humour.*

'Humour,' the philosopher says, 'is an art of the pure events.'**4** What is required is a humour which makes things shoot out and produce a 'becoming-other', in short, the effect of being like a stranger in one's own language. For this humour, the joke is that you are plunged into the *en route.* The event does not require a humour which throws things towards the finality of a punchline. What is required is neither a sarcasm which throws punches, nor a harsh

66

And... South London Art Gallery (1997)

A cycle of repetitious action. Narratives are suggested but suspended. The cycle has different phases of movement: a fitfully animated and exploded tableau of apparently casual acts repeated with mechanical precision.
Photo: Vit Hopley

wit which makes a joke out of the belittlement of another. What is required is a humour which has a sympathy with Zen humour: 'If you have a cane', says the Zen master, 'I am giving you one; if you do not have one, I am taking it away'.

Ask Gary Stevens and he will tell you that what is required is 'half a joke'. What is required is the half of the joke which does not meet a punchline. What is required is the half of the joke which remains in the middle. Two tomatoes are walking down the road, one says to the other...

'However,' Gary Stevens says, 'the joke is, in itself, that two tomatoes are walking down the road.'

The joke is, simply, that the tomatoes are *en route.*

It is as simple as ABC yet never as simple as ABC.

By betraying a world of measurable and possessable things, by being a traitor to the measurable time of the clock, Gary Stevens comes to teach you something about the becoming of the event. He teaches

Notes

1 Gilles Deleuze and Claire Parnet, *Dialogues*, New York, 1987, p.66.
2 Ibid., p.4.
3 Michel Serres, *Rome: The Book of Foundations*, Stanford, 1991, p.216.
4 Gilles Deleuze, op.cit., p.68.

you about indefinite time. He teaches you about fluid states and infinitive verbs whilst, at the same, betraying the persistent desire of our culture to attribute events to a subject. He teaches you about the humour of the 'half joke'. Most importantly, he teaches you that humour can teach something about the coming about of your world. Perhaps it is a hard lesson to learn, one that bends your thought and upsets the apple cart of learning that the A, which stands for apple, always precedes, and is superior to, the B.

So, you may ask, how am I to picture a Gary Stevens event? Quite simply, you cannot think you can picture it by photographing it. This is not because photography 'freezes' the becoming of an event, rather it is because another event occurs – the act of photography itself.

The making of events, as with the making of a photographic image, is always a matter of experimentation. History speaks of battles, at home and abroad; it speaks of someone being run over or the murder of a king. What history grasps of the event is its effectuation in states of affairs or lived experience but the event is in its becoming. The event, or experimentation, is that which is always in the process of coming about. Yes, you could say that the pure event, as with experimentation, is that which escapes history. However, and this must be stressed, the becoming of the event may escape history yet there would be no history without it. There would be no history lessons to be taught, no art history to be written. Indeed, without becoming and experimentation nothing would come about in history. And this is why Gary Stevens's experimentation is historically so important.

Who, or what, today is making events come about?

That's the real question.

67

Bobby Baker

The Rebel at the Heart of the Joker
Marina Warner

3

> There are three things that are real: God, human folly and
> laughter. Since the first two pass our comprehension, we must
> do what we can with the third.
> Valmiki, quoted in the *Ramayana*

> Whatever you do, laugh and laugh and that'll stop him.
> Ingrid Bergman to Ann Todd about Hitchcock and his dirty
> jokes

In a mock heroic bow to the traditional housewife's ability to wash whiter than white, Bobby Baker opens her video *Spitting Mad* with a shot of herself pegging out dazzling laundry on the line. She then snuffs up the smell of it: unlike most advertisements for soap powder, her visuals put in play all the other, baser senses besides sight. Inside, smoothing out the dry cloths, now immaculately ironed into folded squares, she prepares to make paintings: the foods she will use as medium, all taken from the blazing end of the orange-red spectrum, stand on the table; she strokes bottles of wine and ketchup and checks the sell-by dates, bringing the viewer into touch and taste; then she stabs an orange incongruously straight through the core with a stiff index finger, and makes a little 'oops' sound.

The undertow of disturbance beneath the control and paragon of housewifely veneer, the sense of some impending wild loosening and dishevelment has already begun: but nothing will erupt and break surface to shatter the order Bobby Baker's performance

establishes: it just feels as it might, any minute, and the tension is painful, gripping, and eloquent.

In *Spitting Mad*, Bobby Baker applies – parodies? – craft techniques: tie-die with orange pulp chewed and spat out again; she echoes artistic movements of the past, using red wine for an abstract expressionist splatter image; but she also works with her own body directly, without covert references, when she milks the ketchup bottle into her mouth, her head thrown back, and then spews it savagely on to the cloth – with that little nervous smile of women when they know they are not acting quite as expected of them.

The apologetic diminutive 'oops' at the beginning of the video is followed by similar noises – little 'oohs' and 'aahs' punctuate the marking of the cloths; while on the background tape, an arrangement by Steve Beresford of *Besami mucho*, the Brazilian *bossa nova*, plays languidly. The music adds 'Latin' sensuality, the captive's fantasy in the midst of kitchenware banality. But on closer hearing, it connects to Bobby Baker's exploration of the glories and the horror of oral gratification: on the soundtrack, a paean to kissing, on the table, biting, murmuring, chewing, upchucking, and spitting from the highly charged range of oral practices. Her scarlet and yellow effluvia of choice transform the shining laundry into receptacles of body pollution – with reminiscences of sanitary towels, nappies, hospital linen. The film only lasts nine minutes, but it is richly woven, and climaxes with a stunning mock heroic coda to the tune of the ride of the Valkyries, in which Bobby Baker has turned her artworks into semaphore flags and is seen sailing down the Thames, past the Houses of Parliament, Big Ben and the tower of Bankside. On the prow, like a living figurehead, still wearing her trademark stiff white overall, she signals grandly with emphatic eagerness; the image, mocking the portentous and the official, combining the comic and the poignant, the small things and the big issues, packs a strong political punch. The performance sets the artist's skewed and poignant homage to womanly skills, to domestic processes and cyclical necessities of sustenance, against the rigid towers and structures of masculine

69

energy and authority. For her flags signal – to them at Westminster? to us? to herself? – 'Provide better feeding'.

The video was Bobby Baker's first film, commissioned by BBC2 and the Arts Council and created with Margaret Williams. She made it between two live performance pieces in the sequence of five that she has been working on since. *Take a Peek!*, the third in the series, was premiered at the LIFT festival in 1995; *Jelly Game*, the fourth and most recent, explores the urgent fears around children, definitions of innocence and the presence of violence. Bobby Baker will perform it in primary schools, and, in the same way as *Take a Peek!* is constructed as a funfair with sideshows and booths, so *Jelly Game* follows a preconceived form of popular entertainment: in this case, the TV game show, in which the children in the audience will take part. In the aftermath of the Bulger murder and the Dunblane massacre, Bobby Baker began increasingly to notice the level of violent attacks reported daily on the radio, in the press. A typical news item would say, she notes on a drawing, 'A man has run amok with knives in a supermarket in Broadway Green'.

She's not (of course) a law-and-order tub-thumper; the harrowing preliminary drawings she has made to the performance piece reveal, as if through dreamwork, how terrified she is of murderous feelings she experiences. She shows herself spilling out of her own forearm while her open hand is bloodied and armed with a knife. 'It's important,' she says, 'to be aware that you are a murderer, a fascist, that everything is within yourself.' Her view of endemic, individual aggression coincides with the argument of Gillian Rose, the philosopher, in her posthumous collection of essays, *Mourning Becomes the Law*, that fascism must be struggled with: 'to argue for silence ... the witness of 'ineffability', that is, non-representability, is to mystify something we dare not understand, because we fear that it may be all too understandable, all too continuous with what we are – human, all too human'.[1] Fascism, writes Rose, but socially disseminated violence could be included here, retains its hold when it is not faced and challenged through representation.

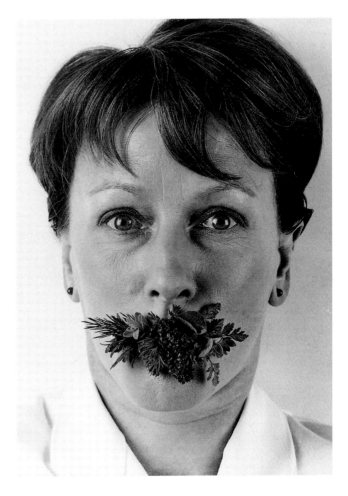

A Useful Body of Herbs (1994)

A special performance and walk through the Chelsea Physic Garden, commissioned by Barclays New Stages for which Bobby planted a body-shaped box to represent herself: lavender (a cure for hysteria) sprouted from her head, basil (good for relieving tension) from her heart.
Photo: Andrew Whittuck

Working with schoolchildren in her local area of London, Bobby Baker has found 'they instantly picked up what *Jelly Game* is about. I went in with a bowl of fruit, and said, 'Let's invent a game.' One boy immediately grabbed an orange, and cried, "Boom, boom, it's a bomb, it's a hand grenade" – I felt I'd come home at last, they understood so well.' The artist spares no one from uneasiness: *Jelly Game* will show Bobby Baker, wearing pink jackboots, as the game show's host, and will implicate her, and ourselves, in both banality and evil.

Take a Peek!, Bobby Baker's preceding performance piece, began with a sequence of intense, personal, coloured pencil drawings, self-

portraits showing the artist in the form of one of those stiff Neolithic fertility figurines, arms by her sides, legs close together. But in her case her body was opening up, showing its bounty – and its poisons. In one drawing, her figure is divided into internal compartments, like a chemist's wall cabinet, and from under the flaps come unpredictable fluxes and oozings ('bodily emissions'). In another, the effigy has become a doll's house, with storeys of furniture and books which the artist has annotated: 'The desire for order – body and household possessions – neat and tidy – PROPERLY LOOKED AFTER'. Other drawings show her head exploding with a burst of silver lucky charms, a breast fountaining with blood, and her body segmented into flowerbeds, 'growing useful herbs'. This woman is seeking to be of service: in one image it looks like one of those Egyptian corn effigies, which were planted with seed and placed in the grave to sprout. These private sketches strip away the comic playacting which Bobby Baker uses to present herself in performance, and they reveal the work's roots in profound and painful self-exposure.

Two years before, in *How to Shop* (1993), Bobby Baker combined the idea of a management training lecture with a housewife's weekly supermarket experience; in *Take a Peek!*, she has taken up the question of women's bodies more directly than ever before, and spliced a woman's nameless ordeals in hospital and clinic with the shows and shies of a traditional fairground. Members of the public are hustled and bustled through in a series of nine moving tableaux and invited at each stage to participate in some way. The highly structured sequence was her most ambitious performance to date. *Take a Peek!*, first staged on the back terrace of the Royal Festival Hall, then toured the UK and abroad in a series of purpose-built spaces and booths designed by the architects Fraser, Brown, McKenna. Co-directed by the artist's long-time collaborator Polonca Baloh Brown, it involved two other actors performing and dancing with her – at the LIFT festival Tamzin Griffin and Sian Stevenson manipulated the artist/patient in their care with false

bright smiles and muscly despatch throughout. In the first booth, Bobby Baker was displayed, bundled up in nine of the starched cotton overalls that have become her signature costume: she's 'The Fat Lady', a freak on show; this corresponds to the 'Waiting Room' stage in the hospital narrative that pulses disturbingly under the whole piece. Explosions of entertainment and circus spectacular interrupt the exploration of the nameless female complaint, as the spectators – taking a peek – follow the artist through the 'Nut Shy', during which she's pelted with hazelnuts, then on through to the 'Show Girls' where she performs an acrobatic dance with the others to a hurdy-gurdy. She is making a spectacle of herself, as Charcot's patients were made to do during his lectures on hysteria in the Salpêtrière hospital in Paris in the 1880s (Freud owned a lithograph of one of these sessions, showing a young woman displayed in a contorted trance, and it is still hanging, above the famous couch, in the Freud Museum.) When Bobby Baker saw the images of herself grimacing, taken by Andrew Whittuck (her husband), she realised they caught the feeling of the photographs that Charcot had taken of his patients – most of whom were women – to illustrate the passions that surfaced in the hysterical condition.[2]

The most distressing tableaux involved the 'nurses' pirouetting as knife-throwers, with all the terrifying associations of reckless surgery; and the acrobatics scene which cunningly and horribly combined expert bed-making with a post-op anaesthetised body and strenuous circus tumbling.

Each phase of her journey through *Take a Peek!* is marked by a fresh, enigmatic, painfully absurd and peculiar sign of the body, as consuming and consumed – oversize melons in a string bag, kumquats swimming in a plastic bag, looking like fairground goldfish, bubblepack ice-cubes filled with Guinness, grass and dirt in a round jug. Each of these signs are again reproduced in photographs Andrew Whittuck has made to accompany the piece, which approach their odd subjects with the cold formal precision of the most highly skilled commercial food photography. The audience of *How to Shop*

also came away with ironically glossy souvenirs: handsome post-cards of items in that show's series of ordeals, like a bowl of crou-tons, labelled 'LOVE'.

When Bobby Baker was a student at St Martin's, the contemporary artists she most liked were Claes Oldenburg and Roy Lichtenstein, and her interest in objects and food was partly shaped by Pop Art's approach. But her time at St Martin's was also the period when Gilbert & George were first appearing as Living Sculptures and beginning to send round their mail art pieces – traces of their breakfast that day, clippings from their hair. But while they have turned to two-dimensional imagery for the wall, Bobby Baker is continuing to use herself as subject and object at once, and to explore pathos and the absurd in daily life.

In 1972, when she first baked a cake – in the shape of a baseball boot – and carved it and iced it, Bobby Baker

> looked at this object, and when I thought of carrying it into the college, as a sculpture, sitting on my grandmother's cake plate, it was as if the heavens opened and light fell on it – it was so funny and rebellious.

Later, Bobby Baker performed a tea-party, offering cakes and meringues to invited friends, and there came a second vision, more painful, and more crucial to the subsequent course of her work:

> I made fun of myself, as I had often done in the past, and every-one laughed immoderately. I was utterly distraught. But then everything began to fit. It was quite the most extraordinary sen-sation. I had been turning myself inside out yearning to be other than myself, but I realised then in one instant that I had to go back into myself, use that and work with that and put it into my art – and that I could do that anywhere

In that discomfort, when she was laughed at, in that clash between the audience's response and the earnest effusions of the caring tea-party giver, Bobby Baker's performance art is rooted. Through it she provides for others, both in reality and in mimicry in such per-formance pieces as *Drawing on a Mother's Experience* (1988) and

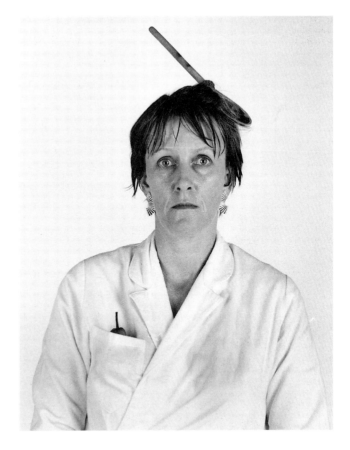

Kitchen Show
One dozen kitchen actions made
public (first performed 1991)

The first of Bobby Baker's 'Daily Life'
series at LIFT'91 when Bobby Baker
opened her London kitchen to the
public. Bobby subsequently went on
tour and opened other people's
kitchens in Britain, mainland Europe,
Canada and Australia.
Photo: Andrew Whittuck

Kitchen Show (1991). She could be called a hunger artist, working
with her own cravings and the common needs of people for suste-
nance, for comfort, for nourishment, of which food is the chief sign
and the chief embodiment in the real world.

The hungers Bobby Baker represents build on her own self-
portrait, and the revelations she makes are so open they
provoke embarrassment. Embarrassment, the emotion
close to the intimacies of shame, also depends on arbi-
trary social codes: it is not one of the grand passions,
the cardinal virtues or the seven deadly sins, but that
does not make it less important, less acutely felt. In this,
her use of embarrassment corresponds to her interest
in working with the most mundane and overlooked

76

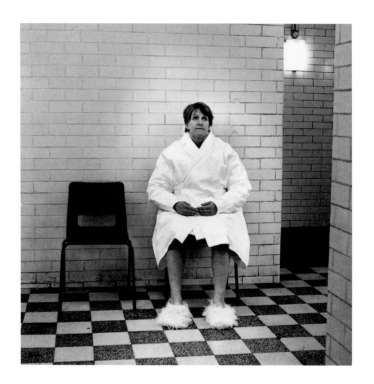

Take A Peek! (1995)

The third in the 'Daily Life' series was commissioned by the South Bank Centre and presented on its Ballroom Terrace during LIFT'95.

Take a Peek! invited the audience to a fun fair, where the grotesqueries of the stalls and side shows formed Bobby Baker's interpretation of the

hilarities, humiliations and surrealism of a visit to a health centre. *Take a Peek!* toured to Arnolfini, Bristol.
Photo: Andrew Whittuck

daily tasks (cooking, shopping) and using everyday materials (pack-aging) and trinkets (a gold ankle chain). But the theatre of embar-rassment in her hands turns out the lining of all these ordinary processes and stuffs and makes them raw and deep; she works with what is concealed in the domestic and the homely and the banal and exposes its complexity and its conflicts, with humour and imagina-tion and reefs of pain.

In the sequence of performance works, Bobby Baker avoids lulling the audience into a false sense of security through her comic self-parody: her art is planned to be raw, unsettling – even violent in its relations between subject and audience. She has defined the effec-tive artistic works as those which

> appear like the structure of a cell rushing through the air, so that you can still grasp it intuitively though all you can see are its blurred edges. This reflects the reality of experience, in which one can't really grasp what is going on.

Attending Take a Peek! as part of the audience should communicate this same feeling of rush and bewilderment, as the audience too are bundled about and asked to do this, to do that, without explanation; in Jelly Game, collaboration with the violent instructions, as in one of those blind tests of human aggressive responses, will inspire insights into one's own collusion and responsibility.

Though the illness or the disorder is never defined – never found? – in Take a Peek!, the piece communicates the female patient's pre-dicament, as she is passed from one investigation or examination to another, each stage appallingly transmogrified into fairground enter-tainments. Each time she is handed on, she sheds one more overall, as if approaching the anatomy theatre for the final operation. However, by a blissful reprieve, in the climax of the piece, she's undressed to take a blessed, easeful bath instead – in chocolate cus-tard. She emerges from this smeared and speckled all over with hundreds and thousands. So Take a Peek! ends in celebration: in the spirit of look we have come through. The catharsis of its ending cor-responds to the bitter-sweet triumphs which have brought others

of Bobby Baker's performances to a reverberating conclusion. In *How to Shop*, for instance, she ascended into heaven on a hoist, a virtuous housewife who has done her job more than properly; in *Kitchen Show*, she tucked J-cloths into her shoes to give herself wings to fly, and then perched herself on a revolving cake stand, with the J-cloths still standing out stiffly from her heels, and memorably began to turn, like a clumsy, poignant, female Eros of the sink and the stove and the cooking spoon.

These narratives of feeding and being fed are highly ambiguous in their picture of home victories. For her first major piece, performed in 1976, *An Edible Family in a Mobile Home*, Bobby Baker made life-size figures out of cake worked on to chicken wire as if the dough were papier mâché, and set them out like figures in a doll's house, in rooms lined with newspapers and magazines: beauty pin-ups in the girl's bedroom where she was lying on the bed, reading, comics in the boy's room. The mother had a teapot for her head, from which Bobby Baker used to pour a cup for her visitors, as she was inviting them in to eat the family.

At the end of the installation of *An Edible Family*, when all that was left of the figures was a stain on the floor and a mass of twisted chicken wire, Bobby Baker realised, as she had not done before, how fundamentally transgressive she had been, how she had in effect made a model of her own brother and sister, mother and father and herself. The experience was distressing, but the work crystallised her approach: in the most normal scenes of everyday life, she would find disturbances. Her art's game of 'let's pretend' reveals how much is truly pretence.

An Edible Family in a Mobile Home defined a powerful and recurrent theme in Bobby Baker's original art of performance: the piece was a profane communion, a family tea-party in which the family was eaten, so that the most polite, indeed genteel, national ritual of friendship became an ogre's banquet. But the artist who nearly twenty years ago made effigies of her own family out of cake can now present herself, at the close of *Take a Peek!*, emerging out of

confusion and physical suffering into the blissful state of gratifica-
tion, a childhood fantasy of pleasure and sweetness, fit for licking all
over, good enough to eat.

This kind of ending is again intertwined with the theme of commu-
nion in her work: it reflects the structure of a ritual like the Mass,
which in its Protestant form does end with the ceremony of the
Eucharist, the eating of the body and blood of Christ by the congre-
gation. The Mass mirrors his passion, death and resurrection, in a
ritual pattern which demands that sacrifice take place before rebirth
and renewal can happen. Bobby Baker's father was a Methodist, and
she went to a Methodist school; her grandfather was so strict that
when she made an aeroplane out of putty on a Sunday, and gave it to
him, he pulped it with a scowl. On her mother's side, there are
'strings of vicars'. She is still a Christian, and owns up to it, an
unusual act for a contemporary artist. But its principles and disci-
pline are intrinsic to her pieces. The abjection she records is bound
up with the idea of suffering and humiliation as a resource; she
inflicts mortifications on her own body, as in the horrific moment in
How to Shop when she put a tin of anchovies in her mouth, under
her cheeks, stretching her face from ear to ear in a ghastly mockery
of a virtuous smile. She has said that she 'wants to share feelings of
no worth, of being humiliated', and does not feel that by enacting
them, she compounds them, but rather gives herself back power in
the act of wilful imitation.

Among the violent preliminary drawings for *Jelly Game* is a bleeding
wound, with a small flattened figure brandishing a knife emerging
from it. She has captioned it 'Oh soft, self-wounding pelican' in a ref-
erence to the hymn which invokes the sacrificed Jesus as the moth-
er bird who, according to the classical and medieval bestiaries,
pierces her own breast with her beak in order to nourish her brood
on her blood. For this reason, in medieval images of the crucifixion,
a 'pelican in her piety', sitting on her nest, often appears at the apex
of the cross. For Bobby Baker, the symbol moves closer at hand: to
the simple maternal feeding and sustaining of family.

79

Cannibalism fascinated the Surrealists, as part of the outrageous trangressiveness they cultivated, and Bobby Baker's work also connects with the movement's aesthetics, in her attention to quotidian details, to discovering in everything and anything the quality of the marvellous – what André Breton called *le merveilleux banal*. The macabre feel of *An Edible Family*, and its burlesquing of gentility, is close, too, to Surrealist staging of street scenes and enigmatic incidents. They used dummies in combination with fabricated objects in order to mount a political attack against the hypocrisy of the guardians of culture and morality then in power. The word 'banal', with its etymological connection to the Greek word for 'work' and its sixteenth-century meaning of common or communal, has been degraded to mean trite or trivial, just as the ordinary work everyone must do has also fallen into disregard, if not contempt. This is especially marked recently with respect to the domestic routines of women and the daily business of mothering – the very territory Bobby Baker makes her own as a arena of art.

Another Surrealist artist, Meret Oppenheim, in several mordantly ironical mixed media objects, likewise explored the connections of the female body and food, of love and nourishment: for example, a pair of bridal shoes trussed and upturned on a dish, with butcher's paper frills around the heels (*Ma Gouvernante – My Nurse – Mein Kindermädchen*, 1936), and the bread roll in the shape of a woman showing her vulva, laid on a chess board as place mat, with knife and fork alongside (*Bon Appétit, Marcel!*, 1966). But Bobby Baker did not merely invite eating in an eternal moment of suspended time; the family was eaten by her guests. This was uncanny, and comic, too, and it brilliantly realised theories of family conflict and the place of food, as simultaneously the symbol of care and love and the instrument of control and authority: 'I'll be Mother' means taking charge of the teapot.

Similarly, in one of the powerfully bizarre episodes of *How to Shop*, she made a baby out of shaving foam, in an appeal to male help and protection – and then destroyed it. The clash within the very core

of the maternal role figures vividly in Bobby Baker's earlier performance piece, *Drawing on a Mother's Experience* (1988), where she is no longer the daughter but the mother, and is herself feeding and being consumed, physically and mentally. It is a most upsetting piece to watch, and a powerful one; it begins with Bobby Baker, bright and cheery, giving a pretty straight account of the birth of her two children and the first eight years of her life as a mother: there's nothing very dramatic recounted – except for the sudden successful deliv-

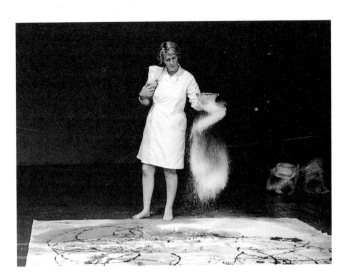

Drawing on a Mother's Experience (first performed 1988)

Cold roast beef, skimmed milk, frozen fish pie, Guinness, Greek sheep's milk strained yogurt, tinned blackcurrants, tomato chutney, sponge fingers, tea, black treacle, eggs, caster sugar, brandy and strong white flour on a white cotton double sheet, 90 x 108 ins. Photo: Andrew Whittuck

ery of her son, on the floor, at home – 'on the only rug I hadn't washed'. At each stage in the story, Bobby Baker remembers some item of food – the Guinness she drank to build up her strength, the fish pie her mother brought her – and produces them on stage from a shopping bag, and then uses them to draw (as the *double entendre* of the title promises) on a sheet she has spread on the floor. The result is a kind of mock Jackson Pollock, an action painting made of beer and blackberries and splattered fish pie. Then, at the very end, she rolls herself into the sticky, wet, dribbling mess and stands up and hops, stiffly, in a kind of celebration dance that she has survived. *Drawing on a Mother's Experience* was performed in a church in Bobby Baker's part of North London the night I saw it. From pref-

erence, she would always perform in public spaces in ordinary daily use, like schools and churches and halls (she initially wanted *How to Shop* to take place in a supermarket), and says that her ideal would be to 'take a stool out into the street and stand up on it and do it' – rather in the manner of a lay preacher. She finds her material to hand, never in specialist shops or fancy, brand-name boutiques; she is developing a vernacular at all levels – dramatic, visual, topographical – and it is intentionally not hip like street jargon, or nostalgic like dirty realist drama dialect, but the particular urban language of the informal unofficial networks, of the usually disregarded working local community. *Kitchen Show* was patterned on a coffee morning among neighbours; she deliberately broke down the distinction between strangers in the street and family in the house, and it was shocking, in a pleasurable way, to be invited into Bobby Baker's own private kitchen to see her perform. She is interested in the ordinary stories people tell one another; in the exchanges that take place between strangers on a bus.

The audience in the church for *Drawing on a Mother's Experience* responded vividly, with cries and sighs, hoots and giggles, but as Bobby Baker worked towards the end, there was a hush and tears. The tragi-comic atmosphere was under her complete command: she assumes a tone of stoical jollity in the way she tells her story, while her characteristic physical bashfulness adds to the excruciating vulnerability she communicates. We learn of what that body has been through, and though her body is on show in some way on the stage, it remains hidden at the same time, under her recurring uniform, the anonymous white overall, and through the conventional gestures she adopts. She says, 'In any place I wear an overall I became faceless and voiceless and I find the possibilities of that really interesting'.

The laughter she causes is not mirth; it is sadder and deeper. It expresses recognition in both male and female spectators of the ordinary human mysteries of life and survival and all their accompanying difficulties she is representing; but it is very far from the kind of col-

lusive laughter that protests provoke. Bobby Baker does not come on as a victim, asking for solidarity in her sufferings. Her re-enactment of her experience as a mother is matter-of fact – no grievances are being aired, no self-pity. But she draws us into her anger at helplessness, and the corresponding terrors of inadequacy, into understanding her confusion at all the demands and the tasks, and the incommunicability of trying to sustain life.

The Surrealist writer and artist Leonora Carrington said in an interview that for her painting was 'like making strawberry jam, really carefully, really well'; she cultivates 'dailiness' and its pleasures. Similarly, the undercurrent of unease in Bobby Baker's pieces rises up to a surface that must be rich in sensuous delights for her. Recalling *An Edible Family*, she talks of the figures' perfect prettiness at first, before they began to rot and to disintegrate (and be eaten); she remembers 'the irresistible sparkle of the sugar against the newsprint'. Her work is consistently concerned with pleasure, with the lively, connected responses of palate and eye, and inspires her to introduce sensuous surprises in every piece, which are frequently funny because they displace sexual engulfment and bliss. Even in the midst of recording the humiliations of the body, she will take a pause to admire – the dazzling purple of plums, the peachiness of some pale pink stuff. It brings to mind something the writer Colm Toibin composed about Egon Schiele, another self-portraitist with a taste for performance:

> Schiele was so brave in the way he let colour decorate his painting, in the way he would allow pure moments of delight to happen, revelling in the richness of the materials at his disposal so that his sense of mingled disgust and desire at the nature of the body is always mysterious and oddly comic.[3]

Partly, Bobby Baker guys herself as a woman, with all the paradoxes that entails. When she was little, she wanted to be a boy, like so many girls brought up in the 1950s with the tomboys Jo in *Little Women* and George in the *Famous Five* as role models. Her name

83

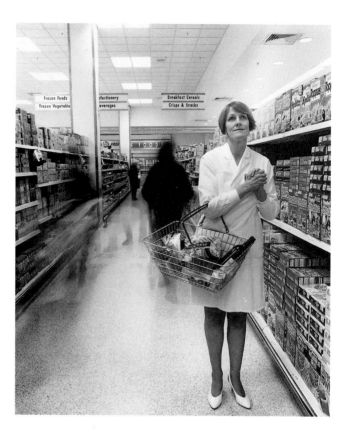

How to Shop (first performed 1993)

How to Shop followed *Kitchen Show*
as the second in the 'Daily Life'
series, and premiered at LIFT'93.
How to Shop took the form of a lec-
ture on the art of supermarket
shopping, demonstrating the possibil-
ities we all have in our daily lives to
transform the ordinary into the sub-
lime. Commissioned by LIFT and
Arnolfini, Bristol, *How to Shop*
toured in Britain, mainland Europe
and the United States.
Photo: Andrew Whittuck

was Lindsey (itself ambidextrous), but she chose Bobby, and stayed
with it. Names are obviously important: in the game of *Happy
Families*, there was Miss Bun, the baker's daughter, and Bobby hated
her for being so round – and red-cheeked, such 'a diminished crea-
ture'. While taking up baking with a vengeance, Bobby Baker was
turning on that fat and happy alter ego who was so supine in her lot.
The figures of women in her work often seem to belong in a game,
too, a game of 'let's pretend' that she is playing. She conveys the
strangeness of all the duties women are expected to fulfil, and her
own ambiguous relationship to shopping and cooking and mother-
ing and so forth put in question the naturalness of such activities for
women at all. She pinpoints the springs of feelings of worth, and
destabilises them, as when, in *How to Shop*, she comments on how
accomplished she feels when her trolley is filled with more bargains

and healthier items than the next person in the queue. The uniform helps here too, as if she needs the costume to perform correctly in the task of being-a-wife-and-mother, but its anonymity and its ungainliness only bring out the imprisonment of gender expectations more vividly. She also seems to affect feminine mannerisms: she has a penchant for baby pink – slippers, slingbacks, even the overalls were to be pale, pale pink. She gives quick nervous little giggles after a phrase in order not to seem too assertive, and to cover up, without really succeeding, feelings of panic and tension. She purposefully adds flurry and fluster in her eagerness to communicate, dipping and nodding in a pantomime of social expectations from carers, mothers, homemakers. This is often excruciatingly funny, too.

Rituals, sacred and domestic, are sometimes structured to include humour; the festivals of Greece and Rome accorded a hugely important role to comedy, in the raucous satyr plays, for example, which concluded the performance of tragedies, and in the Saturnalia, which survive in some form in carnival topsy-turvy. The Christian liturgy used to include the risus paschalis, or Easter laughter which greeted the resurrection of Christ. Anthropologists have shown the link between the way rituals define identity and belonging, and the way jokes, for example, set borders between 'Us' and 'Them', or challenge adversity with laughter and confirm a sense of social solidarity. The court jester was allowed, in the guise of jokes, to tell the truth, as the Fool does in King Lear. Mary Douglas, the anthropologist, points out, 'The joke works only when it mirrors social forms; it exists by virtue of its congruence with the social structure'.[4] She goes on to discuss the joker as a ritual purifier among the Kaguru, the Gogo and the Dogon and other African tribes, where a joker enjoys privileges of open speech others are forbidden, and can therefore cleanse the community; his *modus operandi* is different from the straightforward flouting of taboos, however:

85

[The joker] has a firm hold on his own position in the structure
and the disruptive comments he makes upon it are in a sense the
comments of the social group upon itself ... he lightens for every-
one the oppressiveness of social reality, demonstrates its arbi-
trariness by making light of formality in generality, and expresses
the creative possibilities of the situation ... his jokes expose the
inadequacy of realist structurings of experience and so release
the pent-up power of the imagination.[5]

Douglas could have been writing about Bobby Baker; her use of the
comic mode is interestingly related, given her taste for ritual struc-
tures. The women in her childhood – her grandmother and her
mother – were given to laughing:

they laughed at everything and anything which made me angry –
great hysterical shrieks and hoots. My grandmother was a very,
very frustrated woman – she used to throw things about, and cook
very badly and say things, like 'Have a bun', and then throw it at
you. But this wicked sense of humour was very, very liberating.

Derision was these older women's way of tackling the world. Freud
wrote in a short essay on humour that laughing was a powerful
means of self-assertion:

The ego refuses to be distressed by the provocations of reality,
to let itself be compelled to suffer. It insists that it cannot be
affected by the traumas of the external world; it shows, in fact,
that such traumas are no more than occasions for it to gain plea-
sure ... Humour is not resigned; it is rebellious. It signifies not
only the triumph of the ego but also of the pleasure principle,
which is able here to assert itself against the unkindness of real
circumstances.[6]

The various comic modes on which Bobby Baker draws – stand-up
patter, self-mockery and burlesque, clowning and pantomime – con-
sist of different ways of acknowledging the state of abjection and
making a virtue of it, which is a form of refusal, but not complete
denial. Her crucial change is that her humour does not taunt or jeer
at others, or like a comic, make the audience laugh at others' dis-

Notes

1 Gillian Rose, *Mourning Becomes the Law: Philosophy and Representation*, Cambridge, 1996, p.43.
2 See Elaine Showalter, *The Female Malady: Women, Madness and English Culture, 1830-1980*, London, 1987, pp.147-55.
3 Colm Toibin, *The Sign of the Cross: Travels in Catholic Europe*, London, 1994, p.121.
4 Mary Douglas, 'Jokes', in *Implicit Meanings: Essays in Anthropology*, London, 1975, p.106.
5 Ibid., p.107.
6 Sigmund Freud, *Humour*, 1928, in *Complete Works*, Vol.XXI (1927-31), London, 1953, pp.161-6.

tress (the banana skin principle). She is the target of the laughter she provokes, but remains in control, however weak and vulnerable she presents herself to be. She said once that going into a local church gave her:

> a terrible desire to fall about laughing, or stand up high and just shriek with laughter, because I find it so bizarre – and I have the same reaction in supermarkets. That is really one of the starting points of my work, that irreverence and rebellion and freedom.

Bobby Baker has turned her perception of her own vulnerabilities and folly and anger both as herself and as a woman into a brave show, a new way of fooling: like the jester, she tells the truth but seems to be making mock while she does it, so that we can bear what she makes us see.

Force Field: The Work of
Heather Ackroyd and Daniel Harvey
Sacha Craddock

4

Grass is a living medium, a base, and a fact in itself. It moves, sways and carries the inevitable association of a living agent. Yet when used by Ackroyd and Harvey, it is a construction: watered, coaxed, adjusted, dried, yellow and green. This established, combined artistic practice used to let the medium be both method and message but this has evolved. The medium also carries an extended message. Over time the grass has had to struggle to retain its identity as simply a base; a pointillist ground with individual tentacles that break upwards into space and yet are still part of a cohesive, general and uniform whole.

> Heather Ackroyd and Daniel Harvey have worked together as artists for a while. Their concerns are with organic encroachment and invasion, mineral accretion, erosion and decay; natural forces, whose corrosive, corrupting effects on all our works can sometimes turn to creation or enlightenment. Their work frequently touches architecture. With crystals and seeds they alter or engulf structures and watch their transformation under the effects of air, moisture or light. It is the difference between letting the grass grow and making it grow. They cover to discover; their work brings new textures to old surfaces, fresh visions to tired images. As artists they remain in control; as witnesses to the power of their materials, they are in awe.[1]

Ackroyd and Harvey's work appears to have to come out of a gentler era of experimentation. Light imprinting appears now like early machinery: cartwheels, cogs, iron work and mangles, to be so low-

tech as to be part of nature itself. An image projected on to grass will eventually 'take' and carry the same simple delicacy of an early photograph. Light shines and throws shadows, the shadowy area leaves a light green imprint on a darker area of grass and the nuance of light and shade produces a thoroughly cyclical and yet particularly 'unnatural' relation to nature.

The formal quality of a broken surface that pushes out into the space between the viewer and the wall also puts nature on top of nature in an oddly effective manner. In *Le Ruisseau du Malard* for 'De la Lumière' at the Dazibao Gallery, Montreal (1995), the landscape format suited such a combination. A projected image of an area of the Canadian forest was imprinted on to a wall of living grass and allowed to dry out for one week, creating the equivalent of a browning, faded photograph. The history of landscape painting has both fought against and celebrated the ambiguity of space; the landscape's lack of scale a constant in its representation. A lake may look a puddle from the top of a mountain, a tree a twig and a scar in the land a mere scratch. Classical landscape painting would invariably include a folly, far city, ruin, or wayside hut in order to maintain a sense of human control and keep a hold on an illusion of depth. Instead of choosing to convey the urban environment of Montreal, Ackroyd and Harvey decided to celebrate their new-found enthusiasm for early photography with a landscape image of rippling reflections, repetition, fine line and general texture. This resulted in a pointillist approach; a slice or section of landscape with sky, beaver damaged trees, shattered trunks and upright lines. They were reflected from top to bottom, extended from left to right like a poster in an old fashioned Italian café of an autumnal alpine scene.

Le Ruisseau du Malard continues a constant preoccupation. Although wildness is untamed, there are inevitable contradictions between the notion of fresh unadulterated 'nature' and the method with which it is shown. The grass dies, the almost primeval place itself, three hours out of the city, has been invaded and photographed. Everything is tamed and contained in one way or another. The pho-

tograph is scored into dry grass like a two-page spread across a giant picture book. Video and painting currently reflect an uncertain vision. An 'official' version of anything is impossible. The difficulty of grasping, of wondering what actually did happen, denies a collective sense of past. This questioning of the ownership of account and vision leads to wonderful painting, at best, and can be an excuse for vague insecurity at worst. Gerhardt Richter's paintings of the Baader Meinhof group play effectively with that sense. Newspaper images from the time of the supposed 'suicide' in prison of members of the group, retrieved and painted over a decade later by Richter, beg the question of visual memory and illustrate how impossible it is to freeze a look properly, 'fact' or feeling. In *Le Ruisseau*, the landscape image infused into the massive grass canvas is vague, distant, almost impenetrable and only visible after careful, intense and prolonged looking. Each spectator will be drawn into a different interpretation of this translation of landscape, much in the way that they are encouraged to do in Richter's paintings.

Le Ruisseau shows how the two-dimensional image can convey illusion; how the image comes together with a combination of knowledge and sight. The surface is huge: reaching across from side to side at waist height; from close up the focus is indistinct, making it necessary to move the head and scan to gain a picture of the whole. Knowledge of past representations of landscape merge with memory of actual experience to piece together a 'view'. A multi-magnified drop of water landing in water projected, huge, on to a grass 'screen' grown on the wall of a disused factory in Hamburg, *Reversing Fields* (1995) becomes purely kinetic, retinal and optical; a meditative mantra on an abstracted form. Instead of using any great technological advances, the work was dependent on fundamental procedures. The viewing platform projected into a flood of black liquid where, surrounded by the continuous drip of live amplified sound played in the dark, the reverberating light, dark and shadows encouraged a physical sensation of weightlessness, of being cast afloat.

Theaterhaus Gessnerallee, Zürich (1993)

The exterior of Theaterhaus Gessnerallee building, formerly a military equestrian centre, was covered with 625kg of clay and 275kg of grass seed, watered and grown over one month
Photo: Daniel Harvey

Le Ruisseau's image of a neat mass of coyly rolled virgin lawn turf is a simple suburban victory over nature. But this notion of an expanse of even and uniform grass is a relatively recent addition to gardening history. Instead of extensive parklands with roving model cattle on aristocratic estates the even lawn originated in an industrial age where the fetishisation of nature took a different turn. The whole idea originated with the will to master the urban explosion of the late nineteenth century scientifically, with urban planning. The green space became the residue, the 'negative' effect left over after built structures and traffic patterns. This vision coincides, historically, with the crisp overextended and implausible realism of pre-Raphelite painting. A little-known painting by Charles Allston Collins in the Ashmolean Museum in Oxford, *Convent Thought,* (1850), shows a nun holding an illuminated medieval book standing beside water. A perfect cross section of the fine edge of 'unnaturally' sliced grass is reflected to perfection in the water; there are goldfish, waterlilies, hanging fuschia, and tiger lilies all so evenly painted to a pitch of detail and focus that it adds up to an ineffective whole. Ackroyd and Harvey achieve an equivalent super-realist effect with *Le Ruisseau,* where the spectator is drawn beyond the realism of the image into the reflective, almost spiritual, other world lurking close to the surface of the work.

Within Ackroyd and Harvey's work generally there is a basic contradiction in the use of controlled lighting for the production of an image which has to follow a natural process in order for it to perform properly. The decision not to water the grass means that they are using it blind; more as if it were panel, parchment, or canvas. Direct reference becomes lost in the unconscious knowledge of the material. Surface and subject melt into one another until surface plays a more formal function. Over time, the image projected on top 'takes' (like dyed hair or tattooed skin) and becomes one with the material. The grainy surface of a photograph is therefore reinforced and flattered by the broken vision.

In its attitude to nature, Ackroyd and Harvey's work could be seen

as part of a certain British artistic tradition and taste: Fox Talbot, landscape, classicism, Peter Greenaway; nature as a quality that in its 'beauty' is somehow true or bearing of truths. There is also a relationship with the fusty, musty, decadent decay and destitution with plants intruding and the outside turned inwards; a pastoral view which nonetheless refers, and is dependent on, a sense of human scale, design and endeavour. Harvey talks of a certain circularity in artistic practice; of how an image of a leaf could be printed on to a growing leaf. Ackroyd and Harvey believe that the direct quality of their work is essential. They have a compounding faith in an instant, non-intellectual experience of darkness, light, sound and vision. In the past their work has been hard to categorise and the artists have been happy to allow their 'phenomena' to be perceived as something somewhere between live art and installation. But such characterisations were part of a different situation, one that has changed over the last five years. Whether inside or outside the gallery context, the physical and mental power of large projected film and all-encompassing installation now plays an increasingly large part in mainstream practice.

Site-specific work often carries the 'advantage' of ready-made atmosphere around domestic decay and worn-down industry; there is always ample potential for nostalgia about past lives and existences. For example, in *Esprit Implanté* (*Implanted Spirit*) in Tourcoing, an abandoned leisure centre was brought back to life by Ackroyd and Harvey who used seed, fungi, water, light and clay to evoke the ghosts of a past function. They create a new feeling for the place by emphasising the building's sensuous and atmospheric qualities, and by moving the imagery away from straightforward narration or figuration. Thus the imagery is distanced from the immediate narrative of place. It was only early on, with tableaux or scenes reminiscent of those created by Kienholtz in the 1960s, that they would use a room as repository for vignettes with human-scale furniture, figures and implied histories.

The interior of a barn, grain silo, deserted terrace house, deserted

detached house, Parisian vault, caretaker's flat, cinema complex, or factory offers greater potential than the exterior of a building in the centre of a city, in that they conjure personal, private and domestic associations which can be easily and variously interpreted by individual spectators. A desire for installations and 'happenings' to be effective from the moment of entry is of course different when the grass is on the outside, where the immediate impression is of a public work of art which will be 'read' in the tradition of statuesque monuments referring to broad, universally held values associated with the public realm. For, while it may take one person willing to suspend belief on entering an installation, unconsenting members of the public become both conscious and unconscious spectators when facing a piece that faces the street. For *Theaterhaus Gessnerallee* in Zurich (1993) grass sprouted across the building in a smooth, almost liquid surface from top to bottom and side to side. The fine ridge and slight seam of classical proportion and detail showed in converse relief beneath a blanket of growing green snow. Even the head of the lion over the main entrance was recast in order to grow its own fur. The success was probably achieved through the no-nonsense uniformity of such a stated spectacle. The creation of an exterior grass skin and sound installation contrived to turn the building inside out, conveying something of its history to passers-by. The Theaterhaus had at one time been used as military stables – the soundtape created by Graeme Miller incorporated the repetitive act of grass being eaten by horses into a composed piece evoking the sensuality of the lush skin, filtered through speakers hidden in the grass walls. The life of the grass itself re-flected the development of the building as an arts space.

Ernesta (1995), a framed portrait of an elderly Italian woman, achieved an unusual level of autonomy. The free-standing portrait, printed on grass, attached to a roughly constructed chestnut easel was placed inside a tiny deserted North Italian church near where she lived. Her face was clearly recognisable from the entrance, but her features became unclear, even lost when viewed from close up.

Portrait of Ernesta, Artigianato Vivo, Chiesa San Vito
Cison di Valmarino, Italy (1995)

We took a portrait photograph of an eighty-five-year-old woman, Ernesta, who for the best part of her life has worked the land. The scale of this work was intimate, the framed grass canvas was exhibited on an easel in subdued light within the church. Over the days the grass gradually faded and the canvas became more and more ghost-like. Photo: Daniel Harvey

The dried grass presented a brittle transient quality, a broken surface adding up to a powerful, whole, an especially poignant image in a predominantly agricultural area. Each of Ackroyd and Harvey's works touch a particular tradition within the history of art, and yet on each occasion new materials in fresh contexts are brought into play. Their output has embraced portraiture (*Ernesta*), still life (*Reversing Fields*) and, with *89-91 Lake Street* for the Perth Festival, landscape.

In 1994 Ackroyd and Harvey worked with a couple of empty adjacent 'duplos' in Perth, Australia. They created the equivalent of a journey, with contrasting elements and climates, through the empty domestic rooms. With the aid of various natural and found objects, the series of spaces afforded a great deal of physical control. Instead of creating illusion through two dimensions the passage would encourage a linear interpretation. Again the dominant theme was the transportation of 'outdoor' elements to the interior. A fear of growth, confinement and even suffocation, was counterposed with

Left: *Reversing Fields*, Hammonialle Festival der Frauen, Hamburg (1995)

An image of alternating black-and-white lines reflected in a still pool and then disturbed by a single drop of water was projected on to a 11m x 11m wall seeded with grass. The floor of the space was flooded with black water which reflected the vertical image. A computerised lighting board created a continual ebb and flow between the negative projected image and the positive imprinted image. The optical effect was extreme and disorientating: shifting from negative to positive and back again.
Photo: Daniel Harvey

Right: *89-91 Lake Street*, Festival of Perth, Australia (1994)

Over the course of the fifteen-day exhibition, two tons of red desert sand slowly sifted through the ceiling light fitting, gradually covering and then immersing the table and chair. One of six rooms in adjoining derelict houses.
Photo: Daniel Harvey

Host, Nuova Icona Gallery, Venice (1966)

Plaster form eroded by water, having been submerged in a fast-flowing stream for twenty-four hours. Exhibition in collaboration with Pierre D'Avoine Architects.
Photo: Daniel Harvey

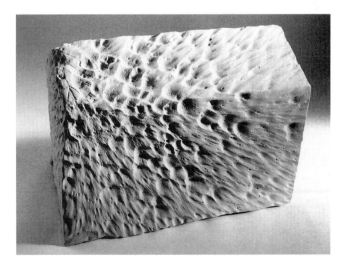

wonder at the use of singular natural ingredients. A dry theme with crystallised camel bones and shifting red desert sand was counteracted by a walk through a crocodile-infested swamp, with fallen trunks and soggy vegetation. This ringing green context was swapped for a charred and blackened room. The physical conditions are both real and contrived; sand would run until it filled up the space, water dripped until the space flooded, and growing shadows imprinted on grass made negatived outline positive and vice versa.

The immensely varied land mass of Australia is a perpetual motif. By setting up the potentiality of nature and arranging it to perform, Ackroyd and Harvey bring a two-way process into play. The comforting idea that this is art, and therefore not real and dangerous, is counterposed with real physical fear. But everywhere an awareness of nature's potential for flood, earthquake, famine, deluge, decay and disaster persists. Even the privileged level of an insurance broker's nightmare is a continuation of an ambivalent relation to nature. Concern about domestic damp, creeping mildew and fungi growing in cupboards reminds us that the poverty which lets it in is never far away.

Force Field (1993) took place in the booming enormity of a nineteenth-century grain store directly opposite Galway Cathedral. The enormous scale of space dwarfed visitors who walked uncertainly along decked walkways over black water. The illusion of great unfathomable depth encouraged vertigo within the interior. Perpetual abstract sound and grass-saturated walls combine to become mythical. It becomes something to travel to see, a phenomenon to visit, experience, and later share. It effects the senses in the way people stop to stare at a street accident, visit an area of natural disaster or ski around the rim of a recently erupted volcano.

The Divide (Wellington, New Zealand 1996) uses grass in such a way that it transforms its normal identity and becomes an abstract sculptural mass. By creating a divide in an urban building, Ackroyd and Harvey employ a method of working which denies associations of a human-scale interior. They move towards a grander more mon-

umental interaction with space and materials. In replacing an every-day structure with a grass-covered void, the artists disrupt an ordinary sense of scale and place and deny commonplace expectations. Such a desire to open up, rather than shut down, the possibilities for interpretation and experience has become increasingly important to Ackroyd and Harvey. The avant-garde artist Lucio Fontana might have sought to transgress formal definition and limitation in the 1950s and 1960s by cutting through the canvas surface but this is different. Ackroyd and Harvey's preoccupation with death, liberation, energy and physical flow comes together in a piece which involves an even greater level of physical interaction and participation from both artist and audience.

Their forceful and direct decision was made after an initial inspection of the site and reflection upon the history and present physical nature of the place. The building, a chunky Edwardian piece of colonial architecture used to serve as an advertising company office and later a theatre. As the decision had already been made that it should be demolished as a potential earthquake risk, it provided an unusual opportunity for the visiting artists to slice through the warm familiarity of the well-known 'tired and benign' landmark. The building was cut, literally wounded, by power tools slicing through the red brick, at such an extreme angle that from many viewpoints the street front appeared undisturbed. This division was therefore adamant and yet paradoxically camouflaged. The work retained the potential for surprise, with the passer-by suddenly confronted at close proximity by an almost dangerous and threatening point.

Instead of a false respect for place or a nostalgia for a past that was not their own, the artists had come to reflect upon the building as raw material with abstract and psychological potential. They reflected on how good it would be to open something up, to release it physically from the past and transform a well-worn combination of habits. The gap between first cut and the removal of the last brick is conceptually non-existent. Clichéd imagery of breaking, tampering, up-ending and deflowering are obviously called into play. Of course,

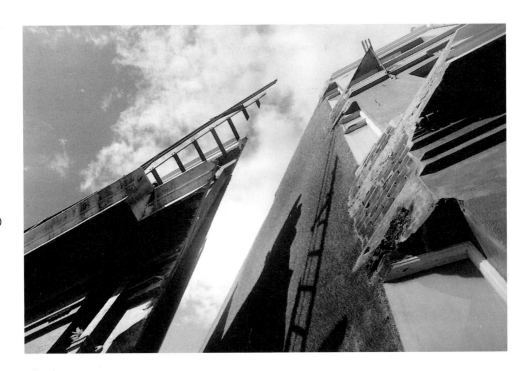

The Divide, New Zealand
International Festival of the Arts,
Wellington (1996)

Our largest scale work to date. The
building was derelict and due for
demolition since it was not proof
against earthquake. A one-metre
section of brickwork was removed
by machine-sawing which left a diag-
onal cut, 17 metres long, running
from one side of the building to the
other. The gaping interior walls
were sealed and then planted with
grass seed, which created two lush
vertical planes; a green fissure in an
urban landscape.
Photo: Daniel Harvey

once sliced open, with no regard for floor level and internal struc-
tural logic, the building becomes a body or carcass. The common-
place experience on seeing, from the top of a bus perhaps, sagging,
falling, flapping details of domestic wallpaper and gutted fire-hearths
suspended high up the side of a semi-demolished building can be
shocking. Here, however, in art practice, as in all art installation,
commercial and domestic detail becomes lost to a more purposeful
rationale. When Gordon Matta Clark sliced through buildings in the
US at the beginning of the 1970s he was making an action each time.
The radicalism lay in the action itself, of splitting or slicing through
the wood and getting out alive before the building collapsed. The
act was mad, fast, individual, fierce and dangerous. In Ackroyd and
Harvey's case, however, the effect of the piece lies very much in its
result; in the creation of a strangely soft but nonetheless discon-
certing space to visit and contemplate.

The Divide made a shallow corridor with no view and no front,
which beckoned, promised a suffocating and exciting experience

Note

1 John Gillet, *Host*, catalogue
introduction, Venice, 1996.

and ultimately liberated obvious spatial expectations. The deafening
softness of the stereophonic mass of grass blurred the senses and
caused the simultaneous desire to slow the steps and retreat into
'ordinary' experience. As in *Force Field* in Ireland an unclear muffled,
mixed and meandering emission played continuously from speakers
hidden with in the grass-covered wall. Thus the excitement of mag-
netic pull, of being suffocated or drowned by height and breadth, is
a mental as well as physical construction. A monumental leaning
steel sculpture by Richard Serra can generate a sensation deeper
and more mysterious than the fear of being crushed.

With this piece, Ackroyd and Harvey use grass to touch on a par-
ticular kind of urban suffocation; on a contemporary colonial claus-
trophobia. An inherent contradiction lies in the fact that the
element giving off such an overwhelming sense of suffocation is
itself organic. Instead of a lining of decayed wallpaper and brick, the
corridor is covered with a substance more normally associated with
growth, space and well-being. The formal and conceptual blending
of soft, fragile, breathing plant matter with bricks and mortar makes
a disruptive metaphor. So with this new division to an old building,
various notions emerge; they range from hope and regeneration
through to reflecting a growing mistrust in the 'green' myth of con-
temporary agriculture. Contemporary concerns about pollution
seem heightened in a country which in the world view seems to
represent both ends of the spectrum and which is itself caught in a
conflict between new associations and old identities. Instead of the
ivy, wisteria, rose or vine that grows bidden up a residential wall, or
the perfectly snipped lawns of early suburbia, their grass plays no
decorative role. Ackroyd and Harvey use the experience and
understanding of a long collaboration to touch on the many forms
of cultural suffocation we encounter in the late twentieth century.
Paradoxically, they provide a form of physical and mental release at
the same time.

Borderland Practice
The Work of **Graeme Miller**
Andrea Phillips

5

Our living depends on our ability to conceptualise alternatives, often impoverished. Theorizing about this experience, aesthetically, critically is an agenda for radical cultural practice. For me this space of radical openness is a margin – a profound edge. Locating oneself there is difficult yet necessary. It is not a 'safe' place. One is always at risk. One needs a community of resistance.

bell hooks[1]

There are many ways to imagine the place of theatre. One is built of bricks and mortar with a red curtain and series of graduated seats; another is an imaginary place full of political juxtapositions and psychological encounters. Since leaving Impact Theatre Co-operative in 1986, Graeme Miller has successfully imagined the place of theatre in and as a landscape. This approach has taken him, literally, from theatre building to urban street to rural pathway in a psycho-geographical trawl of England that has produced some of the most memorable scenes of social alienation and personal and collective resistance of the late 1980s and early 1990s.

Miller is a self-taught composer. His understanding of the musicality of the human voice, the noise of the city or the rhythm of walking providing him with a basic grammar since his experiments at university with other founder-members of Impact. An outsider to the more formal world of composition and musicianship, he works intuitively, understanding the emotional and intellectual response to his

music through his own reaction to it. In the catalogue of works pro-
duced in the last decade – *Dungeness* (1987), *A Girl Skipping* (1989),
The Desire Paths (1993), *The Sound Observatory* (1992), *Listening
Ground*, *Lost Acres* (1994 in collaboration with visual artist Mary
Lemley), *Feet of Memory*, *Boots of Nottingham* (1995), *Hidden Cities*
(1995) – 'composition' is done with words, bodies, films, slides and
objects as well as a musical score. From this effective base, he devel-
ops a complex means of resistance to that which he terms a 'the-
atre of consumption', a theatre that might be more than
entertainment and more than representation.

Miller finds material in the unofficial knowledge of the urban street,
the rural walk and the off-hand conversation. Local paths, houses,
gardens and fields constitute a basic visual language from which he
constructs his work. Using these fragments, he composes a 'map' of
a place or a journey through a place. This map might be construct-
ed sonically or though improvisation with performers (Miller often
works with the same people, building up a climate of knowledge and
mutual interest from production to production). In this sense, he
produces theatre as a score; the score of a journey outside the the-
atre building that is then retrodden inside. 'Botanising the asphalt',
Miller, like Walter Benjamin, searches through the everyday quali-
ties of various territories for clues.

In *The Sound Observatory*, which took place in an empty warehouse
in a shopping centre in Birmingham, Miller, using Islamic geometry,
drew a star on to a map of the city centre, then went to the many
points of intersection and recorded the voices or the noises that he
found there. This music – a direct sound map – was mixed and
amplified through thirty loudspeakers hanging from the ceiling in the
warehouse at such a volume that, in order to hear the individual
narratives, the listener had to stand directly under the speaker. A
year later, *The Desire Paths* then took up this map of the city: five
performers walked with Miller for three weeks throughout
Birmingham, dreaming up and collecting memories of the place,
deriving rhythms, collapsing language into mythical sentences and

103

developing an algebra that they then translated into a work for the-
atre. The artist, to use his own term, 'turned up the heat' on a
series of ordinary practices and everyday codes. This heating
process (this way of making the ordinary special) reinscribes
authorship into secret paths and uncelebrated points; reawakening
memories and re-visioning places.

Whilst remaining very much in control of the process, Miller draws
on the improvisational abilities of his performers: 'I mine the every-

The Sound Observatory (1992)

Casting an Islamic pattern across a
map of the city of Birmingham,
Graeme Miller created a portrait in
sound of the city. Commissioned by
Sounds Like Birmingham during its
City of Music year, *The Sound
Observatory* was a sound installation,
part sculpture, part map, part music,
offering visitors a unique glimpse
into the life of the city.
Photo: Graeme Miller

day', he says. 'A technique we learned in Impact, particularly in mak-
ing *The Carrier Frequency*, was to allow the show to write itself. We
removed the breaks from the ego and worked like a shoal of fish or
in the way that really good improvising musicians might do. It's the
writing on the wall that writes itself'.[2]

The Desert in the Garden

The translation of land to stage began with *Dungeness: The Desert in
the Garden*, described by Miller as 'a small opera about landscape'.
Finding the long, bleak headland that was the subject of the work
reminiscent of a series of iconic seaside commonalties, Miller began
to collect images and record the memories of people that lived on

or around the beach. The resulting work, performed by two actors and two musicians with a score for piano, female voice, piano accordion and tape excerpts, inscribed the beach scene into the theatre with a fleeting, dispossessed, liminal accuracy. Central to this stage painting stood a reconstructed beach hut on to whose back wall film-maker John Smith, inhabitant of the place, projected a series of woven images.

The hypnotic effect of *Dungeness* – its sound score and repeated

105

Dungeness, The Desert in the Garden (1987)

Graeme Miller's first production after leaving Impact Theatre Cooperative was commissioned by the ICA and toured in Britain and continental Europe. In collaboration with film-maker John Smith, Graeme Miller composed, wrote and directed this portrait of a particular landscape.
Photo: Graeme Miller

sequences of actions by actors whose roles, never fully characterised, simply hinted at a portrait of possible lives – was partly constituted by nostalgia for a pre-war England (a beach upon which no nuclear power stations or war detritus appeared) and partly by the abstruse marginality of border country. This marginal seam of land, half on solid ground and half in the sea, inspired the ambivalent 'home' that Miller built in the theatre; a fantastic but preoccupied house in which actors worked in reverie, sleeping, eating and making tea in an uncanny landscape.

Freud tells us that the uncanny is constituted by the unreal seeping into the real and vice versa. This seepage occurs in places that, on first glance, might seem workaday, but on second have dreamlike,

crossover qualities; places that have 'multiple enunciations': hence the shore of Dungeness, the grown-up playground of *A Girl Skipping* and the dysfunctional house of *The Desire Paths*. There is also often, in Miller's work, a contrast between outside and inside, sometimes alluding to the dualism of containment and freedom, but equally tinged with the notion of safety and insecurity, the known and the unknown: like life, Miller seems to be saying, this work is about the dialectic between these supposed opposites:

> There has always been a strong connection between life and art for me. *Dungeness* was a testament to what's what – and what you can't say about what's what. I was deconstructing, making from fragments what was in fact just a momentary flash of a sense of a place, a sense of being in a place, of being in life, pointing back at reality.[3]

For many cultural geographers of the city, like Miller, the idea of place is a social process rather than a demarcated plot of land, an ethos which refuses to divide the spatial from the social, the antithesis of a contemporary disinvestment in reality

His most recent work, particularly that made in collaboration with Mary Lemley, has discussed the ownership of land in terms of psychical rather than fiscal investment; the histories and memories which make paths of desire that are set in the real landscape. 'Layers of a city,' he says, 'belong as much to homeless people as they do to the landed gentry.' But whilst some might say that places in themselves do not contain 'casual' powers but are invested with many political, social and fantasmatic associations, Miller invests in this magical, transcendental effect.

> I hypnotise myself in order to compose. When we worked as a group on *A Girl Skipping*, there seemed to be a devil-take-control command over our actions. Part of this comes from the musical intelligence that evolves when a group of people work together rhythmically. We used walking in circles and getting caught up in the rhythm to release all the breaks that normally stop us from talking nonsense. We developed articulate babble,

'headsong'. We spoke in tongues. I have had direct dependence on things that work despite me. I am dealing with things that are in an encoded form: it's a symbolic understanding that I have which means that, like in alchemy, I am the creator, experimenter or scientist but I will also effect the outcome of the experiment. In a way I have always been through an elaborate process of artifice to try and arrive at a momentary sense of reality: a ritual that takes you back to where you always were.

In *The Art of Memory*, Francis Yates traces the history of 'memory theatres'.[4] This mnemonic system, accredited to the Greek poet Simonides, entails the building of 'houses', 'palaces' or 'theatres' in the imagination, each room of which contains an object, person or series of symbolic actions to which memories are attached, enabling 'tours' of rooms and scenes to reawaken a catalogue of ordered memories. Whilst this method of recollection was practical, it also had roots in a magical attention to memory, and was developed, particularly in the European renaissance, into a cabalistic, occult art that mixed the logical system of the Greeks with the role the recollection of memories might play in summoning powers from 'the other side'. Miller, attracted to the links in this system between the real, the imaginary and the unexplainable, also seeks to construct such systems in which the unofficial knowledge contained in omens, portents and signs held in street names and local lore runs parallel to official history, equal in its enunciation of an 'evidence of lives'.

A Girl Skipping, devised with a cast of six, ends with Miller dressed as a schoolmaster chalking a manic babble of cabalistic signs and alchemical symbols on to a black board whilst the five performers in front of him re-enact a series of eerily profound playground games. These games, adapted through improvisation and word-association to encompass the strangely familiar and sophisticated gestures of children at play, are carried out on the stage in real time. Rhyming songs and rhythmic jumping and skipping games are ritualised through repetition, echoing and following the sound score that accompanies the physical performance. At one point, singing a desolate,

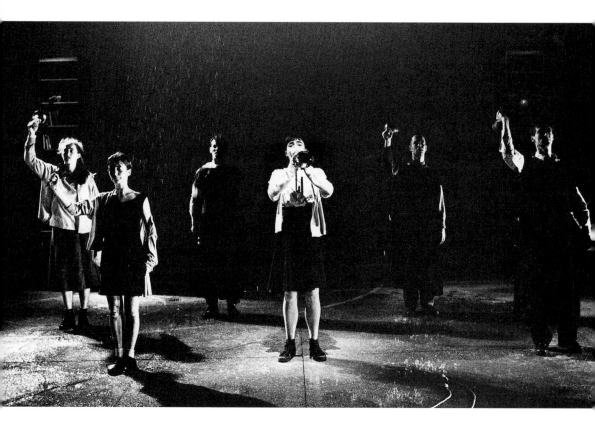

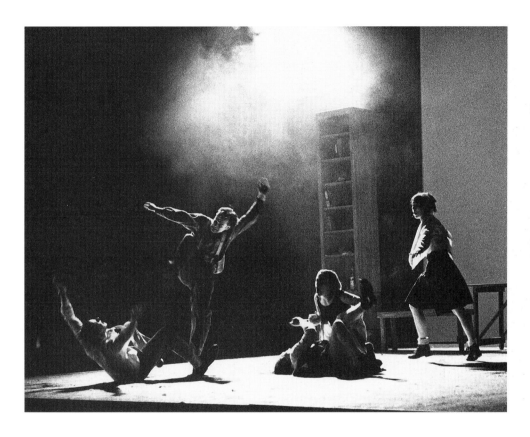

A Girl Skipping (1989)

Graeme Miller's second work was
performed at The Place Theatre and
the Royal Court, London before
touring to the United States in 1990.
A Girl Skipping received awards from
both Barclays New Stages and *Time
Out*/Dance Umbrella in 1990.
Photos. left: Bob van Dantzig
above: Christian Altorfer

repetitive paean to 'England', the performers are drenched in rain from above: a real and visible downpour that fixes the performers' naïve/searching presences clearly on the urban map. The real is suddenly apparent within the illusionary encasement of the theatre building.

Whilst Miller's next project, *The Desire Paths*, worked within the same holding circle, it was also the beginning of his escape from the physical and philosophical constraints of the theatre and towards

The Desire Paths (1993)

The third of Graeme Miller's theatre pieces, *The Desire Paths* was shown at the Royal Court as part of the Barclays New Stages Festival and LIFT'93, and subsequently toured to France.
Photo: Arthur Thompson

that which Paul Gilroy has described as 'uncommodifiable real time'.[5] The alchemical process of 'turning up the heat' on everyday phrases and actions was used again to produce an intense and hypnotic physical and musical score, this time the circle actually stated in the form of a revolving stage. Walking as fast as they could to stay still, the performers acted out an apt metaphor for Miller's growing disenchantment with the possibilities offered by such a theatrical ontology. Towards the end of the work, they built the scene of a walk from the centre to the edge of a city out of various small props on the length of a wooden table: slide projection racks tipped on

their end became skyscrapers; buildings made of cassette boxes and so on. Through and along this, the performers walked with their fingers, telling stories, mixing up fragments of conversations and recounting incidents, people and street names. This escape from the city, this re-enactment of innocence, becomes a metaphorical diaspora for Miller and his colleagues, a walk from one scene of enchantment towards a different and unknowable one in the real world.

Walking out of the Theatre 111

> The ordinary practitioners of the city live 'own below', below the threshold at which visibility begins. They walk – an elementary form of this experience of the city; they are walkers, *Wandersmünner*, whose bodies follow the thicks and thins of an urban 'text' they write without being able to read it. These practitioners make use of spaces that cannot be seen; their knowledge of them is as blind as that of lovers in each other's arms.
>
> Michel de Certeau[6]

In the autumn of 1994, as the finishing touch to a long and pervasive land clearance scheme, the house in the East End of London where Miller lived with his child and partner was knocked down to make way for a new motorway. This loss of his home in turn affected the homeliness of the theatre for Miller, its previously tantalising fiction gradually seeming redundant, its artifice no longer a plausible strategy for defence against the encroaching real world. 'When I finished *The Desire Paths*, my actual desire was for the walls of the theatre to unhinge and fall down at the end of the piece as an inevitable punchline, a punchline that stated "here we are, this is happening". This has been the punchline of almost everything I have done.'

At this time Miller was working on a project in the Wiltshire countryside with Lemley, *Listening Ground, Lost Acres*, in which viewers were invited to undertake a series of walks mapping the landscape and its history. Whilst Miller developed a score for a path from

Stonehenge north of Salisbury to Clearbury Ring to the south, giving participants individual earphones with which to listen to fragments of memories, sounds and music as they walked, Lemley produced a guidebook of walks that criss-crossed the landscape, instructions, maps and writing devised through a process of geographical and poetic local research. Walking, the audience became participants, tied physically and rhythmically into both the mythological and the everyday evidence of lives in the area, each individual inscribing his or her body 'into the text'[7] of the ground. Walking – again, the 'space of enunciation' – allowed this participant-audience to get closer to the text, undoing the more ambiguous relationships of power and performativity that exist in the theatrical audience-performer relationship. Whereas previously Miller had used the theatre to paint nearness, details and particularity of place, he had also developed a technique that would subvert the cathartic illusion of nearness that the theatre so effectively allowed.

Listening Ground, Lost Acres, along with *The Sound Observatory, Feet of Memory, Boots of Nottingham* (a collection of sampled recorded observations by the people of Nottingham over the course of one day) and *Hidden Cities* (a journey on a bus accompanied by sound fragments, stories and 'wordsong' in Birmingham), constitutes a body of work that proposes to shift the relationship between the viewer, the author and the performer into a more discursive scene. 'The more you start to deal with ordinary people and their lives,' says Miller, 'the more you have to deal with. The people who say "Oh well, you've got to make the best of life" have probably nursed their parents through five years of cancer, and what they are saying is an extraordinary act of faith; a grabbing of the reins of life.' Miller's child is disabled, so these ordinary acts of faith are part of his life, and go some way towards constituting the wonder, awe and tenderness that also infuses his work both inside and outside the theatre, translated into terms of hope and recovery in the most desolate situations. His next project will take the shape of another walk, this time along the course of the proposed (but as yet unbuilt) M11, the

Listening Ground, Lost Acres (1994)

Lake Bottom, site from Graeme Miller's collaboration with Mary Lemley, *Listening Ground, Lost Acres*, an installation for walkers in 100 sq. miles of landscape around Salisbury. Sound, bookwork, glass. A joint commission by Artangel and the Salisbury Festival.

Photo: Graeme Miller

site of his former house.

The protest against the building of the M11 in 1994 ended in Claremont Road (the last road to be demolished and the one in which Miller lived). Whilst issues of homelessness and lack of provision were foremost in many minds, at the base of this protest was an anger at the lack of understanding the builders of motorways had for the physical landscape and the fragile, historical and psychological ecology of people and land. The destruction of a series of neighbourhoods wrought by this new road plan has been read as both physical and metaphorical, the replacement of one landscape with another cementing over a series of relationships to location that constituted the active, everyday function of the place. A motorway, built to bring the distant nearer, often has the reverse effect. Cutting through communities, breaking up a carefully woven and unspeakable series of relationships to land and neighbourhood, built expressly for the type of travel that blinds the traveller, measuring nearness in quantity rather than quality. 'I live on a 1970s council estate,' says Miller,

> It's full of people's histories, people's lives that will come and go. It's a rich place that will be what it will be. Motorways and roads in particular are no-go zones for history. They are sterilisers of history. You have to take a leap of faith to believe in reality after they have been built because you can no longer project on to them. These places are simply unavailable. I am now interested in creating a tactical document that will form part of a turning point in the way such schemes are envisaged.

The removal of local democracy, however, occasionally opens up a space of resistance. Michel de Certeau writes of the tactical space of that resistance, an imaginary but useful place where people, devoid of 'the power of the order', turn and pervert the system itself, developing what he terms 'spatial strategies' in which disempowerment is turned inside out through 'its ruses, its fragmentation..., its poaching, its clandestine nature, its tireless but quiet activity, in short by its quasi-invisibility'.[8] This 'art of the weak' con-

tinues, through a process of local participation, practical application and subversive imagination, to construct desire paths across the landscape.

Real Time

> The expanded concept of art is not a theory but a way of proceeding.
>
> Joseph Beuys [9]

In 1988 the US artist Krzysztof Wodiczko made *The Homeless Vehicle* after consultation with many evictees and homeless people living illegally in the streets and parks of New York.[10] The prototype consisted of a supermarket trolley-type structure on to which an extendible metal capsule for sleeping was fitted, with room for storage and a pull-down washbasin at one end. This 'artwork', whilst funded by several city art galleries and foundations, functioned to highlight the problem of 'illegal real estate' in New York, which at that time played host to an estimated 100,000 homeless men and women. The users of the vehicle, like the protesters along the route of the M11 and, in 1996, the protesters at the building of the Newbury bypass, disrupted the hegemonic coherence of the landscape. People who had spent a large part of their lives forced into the interstices and margins of the urban environment, 'trapped by the space of the city', began to possess the space in which they moved. This nomadic capital has a different process and processional, ritualistic set of powers quite unlike those held by the occupants of a static building. Homelessness, entailing the dramatic loss of power that goes with invisibility, was reinvented as a visible, cultural contingent with which the city lives. Suddenly, homeless people had to be seen as part of 'the public'.

Graeme Miller tells a similar tale about the repossession of place, passed on to him by a friend and thus part of a series of stories that relates the cunning of everyday people in the face of power: In Bratislava, a state highway was constructed through the city which not only blocked the front entrance to the cathedral but also

Notes

1 bell hooks, *Yearning: Race, Gender and Cultural Politics*, Turnaround, London, 1991, p.149.
2 Quotations from Graeme Miller have been taken from interviews with the author, one of which is published in *Hybrid*, no.3, June/July 1992, p.46.
3 Michael Keith and Steve Pile, 'The Politics of Place', in *Place and the Politics of Identity*, London, 1993.
4 Francis A. Yates, *The Art of Memory*, London, 1992.
5 Paul Gilroy, 'To be Real: The Dissident Forms of Black Expressive Culture', in Catherine Ugwu, ed., *Let's Get on with It: The Politics of Black Performance*, London, 1995, p.30.
6 Michel de Certeau, *The Practice of Everyday Life*, Berkeley, 1984, p.93.
7 Ibid., p.98.
8 Ibid., p.31.
9 Joseph Beuys quoted by Bernice Rose in 'Joseph Beuys and the Language of Drawing', in *Thinking is Form: The Drawings of Joseph Beuys*, Philadelphia, 1993, p.113.
10 For a full account of The Homeless Vehicle, see Neil Smith, 'Homeless/Global: Scaling Places', *Mapping the Futures: Local Cultures, Global Change*, London, 1993.
11 Ulay quoted in Tony White, *Gordana Stanisic*, Showroom Gallery, 1994.

demolished what was then the oldest synagogue in Europe. But as soon as people were able to return to this site (now an underpass of the highway), anonymous hands began to chalk back the ground plans of the demolished temple in a non-authored act of subversion, community and agency, rejecting the erasure wrought upon their lives.

> [I am] measuring the landscape with my own body
>
> Ulay[11] (performance artist and former partner of Marina Abramovic)

Examples of such resistance proliferate in Miller's work: in *A Girl Skipping*, one of the games that is invented is called 'Love the Dirty Old Man'. One player, bottle in hand, mimics a slobbering, tearful, drunk shouting inane insults and the others have to kiss him one by one. In *The Desire Paths*, the performers find, in building their small roads through the city, wonder and care in the local details of urbanity. In *Hidden Cities*, Miller's own faltering, tumbling monologue leads eventually to a secret and overgrown Jewish cemetery, a garden in the desert of the city, a small shrine to the future filled with memories of the past. Miller's works are full of similar acts of faith, in which hope is called upon to erase the burden of experience, in order that the everyday 'ruse' of living might continue. His deliberate self-exposure is done for the sake of all of us who might wish to re-vision the social within the spatial, reclaim the environment that houses our imagination and develop a discursive relationship to the language and landscape around us.

An Act in Several Parts
The Work of **Station House Opera**
Sarah Kent

6

Performance isn't a game but a symbolic machine...using the
most ordinary, everyday resources for the most unheard-of
purpose.
Jorge Glusberg [1]

Performance art explores the permeable membrane between
art, consciousness and lived reality, always in the present, at its
best always dangerous.
Claire Macdonald [2]

In 1975, while still a student at Middlesex Polytechnic, Julian
Maynard Smith began working with Anthony Howell's performance
group, the Ting Theatre of Mistakes. Five years later he, Miranda
Payne and six others sequestered themselves in a station house on
the West Coast of Cumbria to explore other ways of working, and
Station House Opera was born. Since then, the group has under-
gone numerous changes. Performers have come and gone and Julian
Maynard Smith – the only original member still involved – is, more
than ever, the key figure. Looking back, what strikes one is the con-
sistency of the issues tackled (human courage in the face of the
indignities and absurdities of life, for instance, is explored with wry
humour in numerous ways) and the fact that the performances have
tended to get larger, more beautiful and more ambitious.
The Bastille Dances (1989) is one of the company's most ambitious
and most architectural productions to date. The piece takes on a

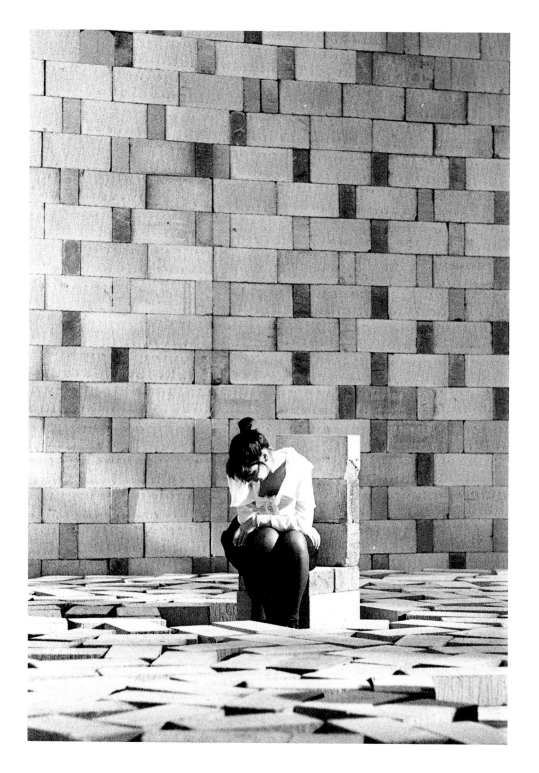

different form in each of the venues where it is performed, but the ingredients remain more or less constant. An elaborate multi-level set, resembling the courtyard of a palace or the main square of a small town, is constructed from 8000 breeze blocks weighing some forty tons. A large wall frames the plaza and a staircase allows performers to move from one level to another: from public spaces to more intimate ones.

In Barcelona there was room to build an eleven-metre high staircase. In Cherbourg the set was constructed inside the Gare Maritime, a beautiful concrete building where passengers disembark from ocean liners and board the train. Echoes of de Chirico – the Italian metaphysical painter who often put trains and boats on the horizons of his lonely cityscapes – were enhanced by the presence of a figure reclining on a plinth, centre stage, like one of the statues in de Chirico's forlorn plazas, as though a painting had come to life. The sense of frozen time, of impotent stasis, characteristic of de Chirico's paintings is replaced in *The Bastille Dances* by feverish activity. The set is not merely a backdrop, it is the primary focus of attention; throughout the piece, performers labour ceaselessly to transform the elaborate structure. An archway is knocked through the main wall and a pyramid built beneath it and numerous smaller structures are created, transformed and destroyed in a continual process of adaption, modification and recycling.

No obvious improvements are made; there is no sense of progress, only of flux. People do not appear to be working towards some glorious goal. No master plan or overview is in evidence, only an endless succession of projects driven by an irresistible dynamic. Periods of frenetic activity are interspersed with quiet moments during which most people rest. Fruitful collaboration is interrupted by outbreaks of fierce competition in which individual schemes take precedence over collective works. Monuments, fortifications, tombs and furniture are constructed as well as buildings. Notes for the performance list Caesar's palace, Marat's room, a prison, boat, fountain, house, arch, wall, garden, forest, box, bed and throne.

119

The Bastille Dances (1989)

A social and political spectacle in which fifteen performers use 8000 breeze blocks as their expressive material. They subjugate, release, support, imprison, undermine, bury and raise each other up through a continuous mutation of forms: walls, towers, arches, articles of furniture, pavements and piles of rubble. Commissioned by LIFT'89 and the town of Cherbourg to celebrate the Bicentenary of the French Revolution. Photo: Bob Van Dantzig

'Everybody has a different idea of what the structure is,' says Maynard Smith.[3] 'Naming the structures was useful as a way of developing the narrative; but this is not a big story, there's no coherent thread. Fragments are set up and abandoned or transformed; someone sits at a writing desk which then becomes a prison. One situation metamorphoses into another.'

Witnessing this constant endeavour is like watching history in microcosm – seeing the evolution of a society, its culture and environment. The breeze blocks evidently symbolise the stuff of the world and the buildings represent the social formations that govern human behaviour, as well as the physical structures that house it. We are used to stories being told from the perspective of individual protagonists, but *The Bastille Dances* offers a dispassionate, God-like overview – a vantage point from which human society resembles an ant colony. Individuals are important only in so far as they contribute to or undermine the common good and opportunities for individual expression are severely limited.

Inspiration for the piece came from the French Revolution, but the performance does not provide a model of an egalitarian society. Much of the action is dominated by a throne. Resplendent in his golden yellow doublet, the 'monarch' who watches over the labours of the populace, lends a hierarchical aura. Other performers take it in turns to work and to relax.

A festive mood is achieved by brightly coloured costumes designed by theatre designer Julia Rapson. 'They were based on clothing worn at the time of the French Revolution,' says Maynard Smith, 'but loosely enough not to be identifiable: I wanted them to be timeless.' The music was written by Ivan Hewitt, an expert on the period. A voice becomes audible as a singer is released from a tower; the breeze blocks are stacked on to another vocalist, compressing his diaphragm and stifling his voice. The release and constriction of the singers reads as a metaphor for artistic freedom and its repression. It is tempting to interpret every aspect of the performance in this way, but literal translation destroys the ambiguity that

gives the piece its richness and complexity. It is possible to see the incessant industry in a positive or a negative light – as a homage to creativity and the human spirit or as a condemnation of the work ethic; as an example of the limitless powers of human endeavour or as a mirror of our boundless stupidity.

'The piece is not idealistic,' says Maynard Smith. 'It doesn't come down on the side of the proletariat or the aristocracy. All the parts are interchangeable, just as all the performers are interchangeable; there's no characterisation.' Despite their lack of individuation, the performers are not zombies. They submit to a regime of hard work that allows scant individual expression, but their engagement with events is actual rather than feigned; they are not acting.

'The performers are in constant struggle with the physical world, but they are not drones,' says Maynard Smith. 'There's a difference between building the pyramids and putting up a garden fence; in life we work like crazy to achieve slender and temporary things. A balance has to be struck between achieving one's goals and being crushed by mindless activity.'

In traditional theatre, interactions are predetermined and governed by narrative; here the absence of a coherent storyline or any character development allows genuine feelings to evolve. The surfacing of actual tensions in real time, rather than their exploration in fictional space and time, is one of the most important and most problematic aspects of performance art. The cathartic excesses of theatre are replaced by the subtler realities of human motivation and interaction. The conflict between individual desire and group ambition creates a palpable undertow of frustration. *The Bastille Dances* not only provides a mirror of the tension endemic in daily life, but also amplifies the stress inherent in working in large performance groups, subject to the will of a director. 'The audience senses the tension between a willingness to become a mindless performer,' says Maynard Smith, 'and the desire to establish one's individuality. In rehearsal it's important to weed out those who look like bricklayers doing a job; who don't convey the wish to rebel.' Yet the

piece is carefully choreographed. 'Much as architecture may dictate a way of going about construction,' wrote Anthony Howell, founder of the performance group the Ting Theatre of Mistakes, 'choreography may well result in a monument.'[4] The most striking aspect of this beautiful and ambitious work is its fluency. Structures are built, modified and demolished with balletic precision. 'There has to be a flow from scene to scene,' says Maynard Smith, 'keeping a rhythm is the dominant requirement.'

Moments of absurdity punctuate the hard work; someone freezes, poses like a statue or feigns unconsciousness. Responses vary from propping them up or walling them in to carrying them off like a corpse. Yet despite these flashes of humour, the labour seems relentless; one longs for those silent workers to rebel. Audiences cheer when a tower is pushed over immediately after its completion and the conflagration that brings the work to an end is similarly cathartic; it releases pent-up frustration.

Flaming breezeblocks topple one another the length of the staircase, like dominoes, and set fire to the throne. Destroying the edifice on which so much effort has been expended is like blowing up the bridge over the River Kwai, despite the lives and labour that it cost; it is a means of regaining one's dignity and asserting one's will. But the meaning of the conflagration is unclear. The fire might also represent Armageddon – the destruction of humankind.

Having studied at the Bartlett School of Architecture, University College, London, Julian Maynard Smith is well qualified to employ building as a metaphor for human endeavour. 'I'm still interested in architecture,' he says. 'But it's more fun doing it outside the profession.' The sets are designed so that if anything were to collapse, no one would be badly hurt; the large structures have to withstand high winds and this limits the potential for improvisation. 'You can't improvise when several tons of blocks are needed in specific places,' says Maynard Smith, 'but each performer develops his or her part in rehearsal.' He and Bruce Gilchrist produced a book illustrating breeze block structures that can be modified, extended or combined

Dedesnn-nn-rrrrrr (1996) was an elaboration of *The Bastille Dances*. A complex, operatic set – a colonnade fringing a plaza – was built in front of the ruins of the Frauenkirche, the church of our Lady, the tallest protestant cathedral in Europe. The context gave the work particular resonance. During the Second World War Dresden was all but destroyed by allied bombing. The Russians rebuilt the city, but they left the cathedral untouched. Looming over the set, the ruined choir encouraged one to see the piece as a metaphor for the destruction, reconstruction and reunification of Germany. A tall chair behind a high wall, for instance, became a watchtower. 'In Germany building a wall takes on political significance,' says Maynard Smith, 'but the piece does not have a single meaning.'

The music was composed by Agnes Ponizil. The rasping sounds of a cello and violin were heard as, one by one, the musicians were released from the small cells in which they were incarcerated. They were joined by a recorder and harpsichord, and incoherent noises evolved into elegant baroque harmonies. Later on, jazz syncopations began interweaving with these melodies. Other links between past and present were suggested by the costumes. White clothes were printed with photographs of the porcelain figurines made nearby in Meissen.

The piece was choreographed as tightly as *The Bastille Dances*; the building work was executed as fluently as a dance. But, occasionally, co-operation broke down and performers began pursuing their own goals, stealing materials and sabotaging one another's projects. Yet the rhythmic fluency of their actions made it apparent that the rebellion was prearranged. 'In the major pieces,' says Maynard Smith, 'disobedience is performed rather than genuine. There's no opportunity for the demonstration of will.'

A cabaret provided humour, the acts being, by turns, gruesome and comic. The finale involved the fall of a line of blocks, set up like dominoes, and an explosion in a small chamber followed by the escape of the occupant. The toppling of the Berlin Wall and the collapse of the Communist regime came to mind; but the piece avoids

123

precise political analogies and, instead, offers a model of ongoing struggle. There is no resolution, only the acknowledgment that utopia is never achieved.

Station House Opera first used breeze blocks in *A Split Second of Paradise* (1985). Based on the Creation myth as told in Genesis, the piece narrates our expulsion from Paradise, the first utopia. To enhance the sense of familiarity, performers adopt poses that echo well-known paintings and sculptures, such as Michelangelo's *Pietà* and heroic images of the dead from war memorials.

The speaking part of God is played by Julian Maynard Smith. Having made a perfect world, the Creator considers whether it is possible 'to invent something with the seeds of its own falsity' – cue to raise Adam and to introduce Eve. 'You shall do nothing,' He proclaims, 'for the experience of doing shall corrupt your innocence.'

A woman arrives with a breeze block that inspires the couple to build. God curses them: 'You will carry those blocks for ever'. A man joins them and they devise numerous structures including items of furniture, like a bed and dressing table, that promote the 'sins' of lust and vanity. They explore various ways of interacting with one another and with God, who is elevated to a great height before descending to die on the cross. The piece offers, in microcosm, the story of humanity's evolving awareness and sense of society. Like *The Bastille Dances*, it also offers an uncanny reflection of the developing identity of Station House Opera as a performance group. Julian Maynard Smith's description of the production is an apt summary of the working methods of the young company.

> *A Split Second* is an exploration of idealism, of a new world to be shared, argued about and fought for. It's about putting yourself in a difficult situation and coming across a bit of luck, or being hoist by your own petard. It's not the self-mutilation school of performance art, but it admits the possibility of it. The punishment for being kicked out of Paradise was hard work, danger and physical pain.

Many of the ideas developed by Station House Opera – exploring the 'conflict between freedom and adherence to rules'[5] and using furniture to cross a space without touching the floor – stem from exercises developed by Anthony Howell for the Ting Theatre of Mistakes, which Maynard Smith had joined in 1975. Howell had published these as *Elements of Performance* (1976) with Fiona Templeton. The programme notes for *Homage to Morandi* (1980), a performance which Maynard Smith helped to shape, reads like a description of Station House Opera's later work *Cuckoo* (1987).

> Items of furniture are not used as 'props' but as partners in the work – the manipulated and the manipulators becoming interchangeable. Performers arrange and are arranged in turn ... *Morandi* is a work of oppositions, animate and inanimate, the figurative with the abstract, life with art.[6]

Howell's approach was resolutely abstract and formalist, and Maynard Smith found this increasingly limiting. 'I wanted to use physically expansive actions and play with narrative,' he explains. 'It's more of a challenge to bring rules and structures into conflict with the real world, challenging physical laws such as gravity.'

In 1980, Station House Opera was formed. 'We sailed into the theatrical world from art school without any baggage,' recalls Maynard Smith, 'without self-consciousness. We rehearsed seven evenings a week in damp basement and it was very stressful; there was a lot of screaming.' The outcome was *Natural Disasters* (1980) a reaction, says Maynard Smith,

> against the repetitive behaviour scenarios of the Ting – building a sequence of actions and adding things. We wrote the script as we went along; everybody contributed. I was trying to discover how to enact a narrative without acting and how to describe behaviour in an abstract way, when it's normally content-full.

Jorge Glusberg has identified social life as being 'one of the principle sources of meaning in performances. We do not allude to everyday and vulgar ceremonies', he writes, 'but to unexpected events, which force conducts to be altered and prior behaviours to be evaluated

in order to adapt them to unusual, unforeseen circumstances.'[7]

Natural Disasters was based on a dream about a volcano erupting and lava pouring down the street. Julian ran into a room with several others; they barricaded the door with furniture and were saved. In the next two acts the dream is replayed, but the behaviour of people and objects is modified by knowledge of the previous sequence, so that the threat diminishes and fear is accommodated. From 1985 the core group was Pascal Brannan, Julian Maynard

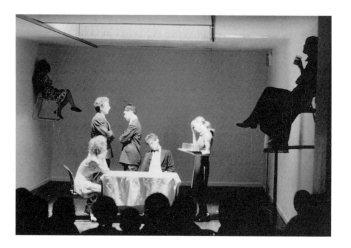

Natural Disasters (1980)

Station House Opera's first performance, a construction of broken intentions where actions are endlessly diverted into others. As an exploration of human flight, it was defeated by gravity and became a drama of spatial and behavioural distortions.

Photo: Rob White

Smith, Jo Miles, Miranda Payne and Alison Urquhart. Bruce Gilchrist joined in 1987, the year that Station House Opera first received funding from the drama panel of the Arts Council of Great Britain. *Cuckoo* (1987) was the first production for which the group was properly paid and, once again, the piece reflects their situation – of relative economic security. It could be described as a comedy of manners. Rather than battling against overwhelming natural forces and the instability which they symbolise, the performers strive to establish domestic equilibrium. The threat comes from within, it comes from differences with colleagues or it comes from their own conflicting desires.

At Riverside Studios, London, large quantities of junk shop furniture – chairs, wardrobes, tables standard lamps and carpets – were

arranged as though in a showroom. As in *The Bastille Dances* and *A Split Second...*, the participants grapple with recalcitrant materials but, whereas breeze blocks are neutral and standardised, furniture is designed for specific purposes and has particular resonances. The interactions of the performers reflect this and their exchanges carry psychological, social and domestic inferences absent from later productions.

Precedents govern the way that one relates to household items, and the humour of *Cuckoo* arises from determined efforts to maintain this etiquette when circumstances mitigate against normal behaviour. Carrying on as though nothing untoward had happened is a peculiarly British trait and, with its bedsit furniture, *Cuckoo* has a strongly national flavour.

Carefully orchestrated sequences allow performers to switch roles from those aiming to achieve tranquillity to those disrupting it. Alison Urquhart carries Bruce Gilchrist on stage while he is frozen in a seated position. She sits him on her knee, then manoeuvres herself on to his lap. He falls over and she arranges two tables and a chair round him. Sarah Rapson places a chair over Pascal Brannan's sprawled body and stands it upright. Both men now appear to be seated; normality has been restored, more or less.

From now on problems – such as table or chair legs of differing lengths – are resolved with whatever comes to hand; a section is sawn off or a teacup placed underneath. The performers are endlessly resourceful, but they continually subvert one another's plans so constant adaption is necessary. Feelings are translated into physical equivalents. Alison and Pascal cling to a carpet which they believe to be vertical, like a cliff face. Perched on a table and chair, they desperately nail the carpet to the floor. Sarah removes the furniture, but they do not fall; their fears were groundless. Julian makes advances to Alison, she pushes him way; he falls and is saved by an item of furniture. The action is repeated more and more dramatically, Julian being saved, each time, by an item of furniture.

The work operates on two levels – as poker-faced situation comedy

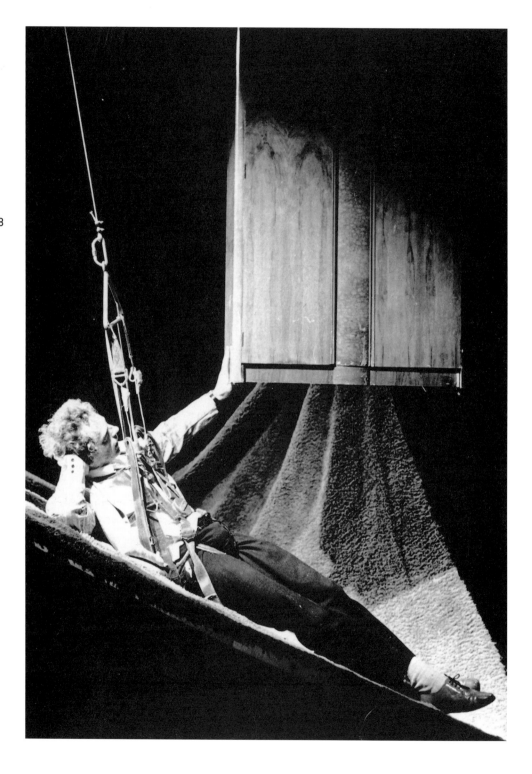

and as a series of metaphors for experience. Resources gradually dwindle as the furniture is sawn up, and people's options diminish accordingly. The women end up nailed to chairs and Pascal to the floor. Bruce and Julian don harnesses and raise themselves on to a platform suspended from the ceiling, where they lay a carpet and lower a wardrobe. Bruce lies nailed to the deck, reading, while Julian hangs in midair, his weight counterbalancing the wardrobe. All are stuck.

Cuckoo (1987)

Here the inertia of furniture is removed, it is no longer in the way, filling empty rooms. Performers are nailed to it, it is sawn into pieces, balanced, wedged and dragged as they attempt to elevate themselves in these surroundings.
Photo: Alistair Muir

129

Slapstick is avoided by the slow deliberation with which each action is performed. Their responses to circumstances seem appropriate, if short-sighted. The ultimate impasse arises because there is no master plan or overview; people muddle along as best they can, unable to think ahead.

The symbolism is self-evident. With its wry humour, the piece exemplifies what, according to Jorge Glusberg, matters most in performance: 'observation of the internal *vis-à-vis* the external, of the small *vis-à-vis* the monumental, of the suggested *vis-à-vis* the unequivocally evident'.[8] The second-hand furniture is a reminder that we inherit a world already filled with objects and beliefs and governed by rules and rituals. Rather than inventing something new, creativity involves improvising with existing ideas and materials. 'The spectacle of people coping,' says Maynard Smith,

> What is happening physically is a magnification of what is in their heads, an expression of internal states. A performance is successful when two things marry when, rather than being a piece of circus apparatus, a levitating carpet acts as a metaphor for instability, the unpredictable, the unwelcome. The spectacle is a way of expressing that physically rather than through acting.

His remark echoes Jeni Walwin's analysis of performance; she singles out 'the need to manipulate materials in a physical, visual way and the desire to distinguish between putting on an act and being there'.[9]

In contrast to *Cuckoo*, *Black Works* (1991) offers the performers a blank slate. The floor is covered with a film of flour that falls from

the ceiling like fine snow. Using brooms or their bodies, the partici-
pants leave marks in the white dust. Contributions vary from
impromptu body traces to abstract designs, figurative drawings and
cartoons – from high art to popular culture, from individual expres-
sion to programmed action. Some work blindfold, others wear
headsets and obey instructions that only they can hear.
Contributions are repeatedly modified or erased and, from time to
time, a fresh fall of flour provides a new start. As in *The Bastille*

Dances, a quasi-historical overview is offered in which the contribu-
tions made by peoples and cultures are destroyed by those who
follow.

After *Black Works*, Julian Maynard Smith spent a year as artist-in-res-
idence at Kettle's Yard, Cambridge which gave him the opportunity
to explore his ideas in terms of sculptures and installations, as well
as performance. *Torso* anticipated the set for *The Bastille Dances*, on
a small scale. Balanced on a swing, six feet above the floor, was a

complex structure made from breeze blocks. Other pieces have a disarming, Heath Robinson absurdity. With its plastic urn, can of Heinz beans stuck with nails and a spotlight casting dramatic shadows, *Toy 1* is a motorised echo of Duchamp's *The Large Glass*, its elements endlessly revolving in a jerky approximation of frustrated desire.

The exquisite tension of Station House Opera's performances often arises from conflict between individual desire and collective need. Required to expend most of their energy struggling with recalcitrant materials, performers have little time for introspection. Conversely, the pathos of these sculptures comes from the way that their squeaky mechanical actions approximate human needs and desires. *The Solitary Drinker* consists of a table, chair, wine bottle and glass which ascend gracefully on separate wires and come to rest upside down on the ceiling, before returning to their original positions. With no one to complicate matters, the mechanical ballet continues fluently and without interruption. In contrast, one recalls the mayhem of *Drunken Madness* (1981-3), performed under Brooklyn Bridge. Diners sat on chairs or lounged on tables suspended in mid-air from steel cables. They yelled their orders to waiters whose harnesses enabled them to defy gravity and move up and down between tables. Fights broke out, tables were overturned and crockery rained down. People, it seems, are the problem; drunkenness, anger, frustration, need and greed inevitably lead to conflict. Without them, there might be a sane and ordered universe.

Dignity, however, can be regained. 'When drinking yourself under the table, it is good to come back through the door', read a notice on the wall at Kettle's Yard. It referred to a plywood room, open on one side like a stage and occupied by a table and three chairs. Beneath the table, an opening led into a tunnel that gradually increased in height, enabling one to recover an upright position, and make a seemly reappearance.

Station House Opera's return to the stage was with *Limelight*

Black Works (1991)

In a black space a fall of flour covers the floor and the performers; thenceforth their every movement leaves a mark, black on white. Every mark is ephemeral, replaced by other marks, covered by other falls of flour. Performers invent their stories in this empty, but ever more complicated, world.
Photo: Bob Van Dantzig

(1995). Visibility – how to achieve it, control it and retain it on stage – is the overriding issue. The work harks back to the invention of limelight which first enabled actors to leave the footlights yet still be seen. Once more, performers grapple with the elements. Using welding torches, they heat pieces of lime to white-hot incandescence. The ease, constancy and subtlety of electric light is replaced by a demonic glare that flares up, dies away and is difficult to control or maintain. Light, the symbol of reason and clarity, becomes unstable, volatile and expressive. Seeing and being seen both become problematic. In Copenhagen, the piece was performed in an ex-turbine hall, an appropriate setting for a work exploring the era before electricity. The huge Victorian building gave the work a diabolic aura, as though satanic industrial scenes were being re-enacted. Monstrous shadows cast on the tiled walls evoked the lighting of expressionist films like Fritz Lang's *Metropolis*, which dramatises the horrors of industrial slavery.

Performers huddling over bowls of incandescent material brought to mind the demonic practices of alchemy and black magic. Yet when it was performed on the roof of London's Queen Elizabeth Hall, the piece acquired an almost romantic aura. There were no looming shadows and the hiss of the gas jets, that indoors had sounded raspingly dangerous, was diffused by the wind. White balloons and an accordion player created a party mood that was enhanced by the richly coloured silks worn by the participants.

Some performers struggle to provide light, others bask in its glory. Two women, posing on gantries that rise and fall in a choreographed sequence that mimics the nocturnal workings of a building site, bring to mind pin-ups and famous paintings. Improvising with metal plates as light-reflecting halos, a couple assumes various iconic poses. Images of saints and martyrs merge with film-star stances as they rehearse their role as a spectacle. The spectre of flash-gun photography and the self-consciousness of those caught in its glare, haunt the scenes.

A sense of danger infects banal actions. A woman caught in a shower

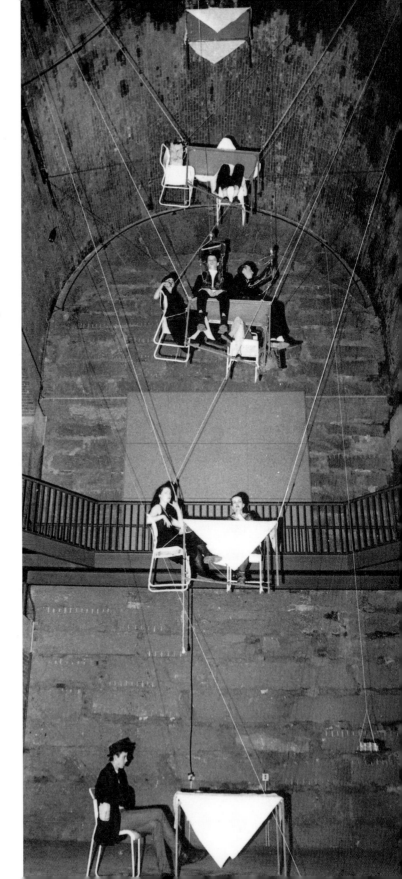

Drunken Madness (1981)

With all the wires showing, tables
and chairs hang above one another –
another conversation with gravity.
Two waiters, counterbalanced rise
and fall from top to bottom. At the
tables, the drinkers become drunk,
their intemperate movements desta-
bilising the entire machine.
Performed under Brooklyn Bridge
for the Bridge's centenary in 1983.
Photo: Robin Holland

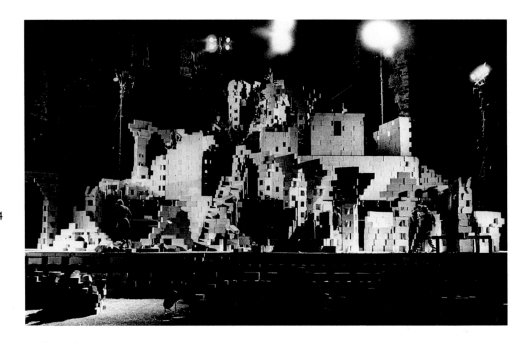

134

The Salisbury Proverbs (1997)

Continuing the sequence of perfor-
mances with breeze blocks, commis-
sioned by the Salisbury Festival.
Located by and inspired by the build-
ing of the Cathedral, it consists of a
network of proverbial and allegorical
narratives given an architectural
and sculptural form – a version of
Breughel's *Netherlandish Proverbs*.
Photo: Bob Van Dantzig

of molten steel protects herself with a metal hat. Two diners
become the focus of frenetic activity. Oysters and a chicken are
'cooked' at table with welding torches and a diabolic barbecue
ensues in which the calcium in the shells and bones produces a
primitive form of limelight. The diners try to spear pieces of incan-
descent lime with their forks as they fall, like manna, from heaven.

In Copenhagen, the piece ended with a woman hanging like a
corpse. In London, the exploding of balloons containing powdered
lime momentarily blinded the audience and signalled that the party
was over. '*Limelight* hasn't really got an end,' observes Maynard
Smith. 'It's like a glacier, a natural phenomenon. Bits fall off, but
something else always comes after it.'

Talking to him, one becomes aware that the performances he devis-
es are an embodiment of his philosophy. 'Existence carries on,' he
remarks. 'You can't do anything about it. There are no resolutions,
there's no catharsis. The problems always return, the misery seeps
back in. What else is life, but nice sunsets and bits in between?'
Over the years, the themes have remained remarkably constant. As

Notes

1 Jorge Glusberg, 'Towards a Theory on the Art of Performance', in *The Art of Performance*, colloquium brochure, Palazzo Grassi, Venice, August 1979.
2 Claire Macdonald 'A Lot Less Shouting', *The National Review of Live Art*, Tramway, October 1990.
3 All comments by Julian Maynard Smith were made in conversation with the author during preparation for this essay.
4 Anthony Howell, 'The Tower', *Performance Art and Video Installation*, London, 1985, p.15.
5 Anthony Howell, *Scenes at a Table: Homage to Pietro Longhi*, Serpentine Gallery, London, 1976.
6 Theatre of Mistakes programme notes, Jeanetta Cochrane Theatre, London, 1980.
7 Jorge Glusberg, op.cit.
8 Jorge Glusberg, 'The Semiotic Achievements of Performance' in *The Art of Performance*, op.cit.
9 Jeni Walwin, 'Performance Art in Britain 1985-1987', *Live Art Now*, London, 1987.

a student, doing solo performances, Maynard Smith explored the disparity between inner and outer states, between thoughts and actions individual desires and social demands. He would establish a system whose inherent drawbacks required the head and hand to perform discordant actions. He then strove to accommodate conflicting rules and to make his actions match his desires. The goal was to conform, and tension mounted as the disjunctions became apparent. A conjuring trick or sleight of hand would be employed to prevent a breakdown – a theatrical device that is the equivalent of cheating and criminality of lateral thinking and creativity.

In Station House Opera's performances, the desires and ambitions of individual participants are frequently frustrated by physical or behavioral constraints. It is up to the performers to make space for their own needs, while collaborating with colleagues and struggling with the material world. The imposition of silence is a favoured constraint. Denying performers the opportunity to express their thoughts symbolises all manner of repressions. Negotiation is made difficult and behaviour becomes ritualised. But in British culture, where actions are largely governed by social rituals and people are expected to control their emotions, the restrictions do not seem improbable. The frustration and conflict that result, the absurd situations that arise and the sardonic humour that relieves the tension give the performances a psychological resonance that rings true to ordinary experience.

The Art of the Magician:
The Work of **Keith Khan**
Naseem Khan

7

Let me come clean. I have had problems writing this piece. Time and again, I rethought: fiddled, rewrote, worried. Then it occurred to me that in situations where no answer is evident, one should re-examine the question. Perhaps it is not a case of, 'How does Keith Khan fit into the postcolonial discourse of contemporary cultural studies?' Perhaps we should simply start with Khan – an elliptical creator of large-scale illusions whom it is hard indeed to categorise – and see what comes to the surface.

The background for this elusive artist is quite clear. Khan is one of a generation of young black artists seizing hold of all the gamut of forms that the umbrella term, 'Live Arts', allows, and putting their own stamp on them. Keith Piper, Mona Hatoum, Rita Keegan, Nina Edge, Ronald Fraser-Munro, SuAndi, Lubaina Himid and others have all demonstrated what Catherine Ugwu in *Let's Get It On* (1995) described as complex 'historical legacies and acts of cultural resistance'. Keith Khan is one of the most ubiquitous and – apparently – most accessible. Sculptor, installation-artist, Carnival designer, instigator of large-scale spectacles and mixed media productions, he is a determined polymath. The last few years have seen him exploring a varied range of approaches and techniques with an absence of set boundaries that can be challenging as well as refreshing.

Wigs of Wonderment at the Institute for Contemporary Arts (ICA) in 1995 (and revived a number of times since) manifested many characteristics. Its overt subject matter – human hair – is a compelling theme. St Augustine warned young monks never to let

Wigs of Wonderment, Commissioned
by the Institute of Contemporary
Arts, London (1995)

The image shows Georgina Evans
giving a massage. At every location
for this show, the interaction with
the public was radically different,
although each depended upon a
one-to-one experience. Issues of
blackness were central to its cre-
ation but, as the project evolved,
questions of gender and the femini-
sation of men were raised. It was
rewarding to engage closely with
the audience during the process.
Photo: Ali Zaidi

women wash their hair for them; Rapunzel's potent hair had to be cut off, and so did Samson's. Throughout myth and folklore, hair has been seen as the site of power, control and sexuality. It is not surprising that it has recently drawn a number of contemporary Black artists to its symbolism, including Rita Keegan and Sonia Boyce. Its ambiguous aspects, its connection with danger, racism, sexuality and power, were woven into *Wigs of Wonderment*. It was designed to provide an unfolding experience, via a sequence of events and installations devised by Khan.

Audience members were first of all assembled and told to wait in a coloured tent. It was empty except for a number of plinths. On top of them, like a parody of a chemist's display, stood a number of bottles, tubes and jars imported from Africa and the Indian sub-continent, all of them containing substances that promised to change people's appearances: straighten their hair, lighten their skin colour, enhance physical 'beauty'. Small groups of spectators were eventually beckoned through a dark curtain made of hair into in a small and rather intimate space. It contained two make-up tables attended by two young Black beauticians. They welcomed and seated people, and tried a number of different wigs on them. The women's tone was confidential and kindly. Did anyone have problems with their hair? Or with their skin? They were solicitous yet knowledgeable, only occasionally carrying a sense of coding: 'Your hair's very curly', they might say, with just a hint of a value judgment. The exchanges were comparatively oblique, but they were intended to focus the attention more closely on what constitutes and who defines beauty, a theme that had been suggested in the waiting-room.

After this, participants were directed through a dark gauze curtain. This led into a tunnel at the end of which stood a very tall wig, columns made of hair and a throne-like hair chair. This space was managed by two Asian men wearing furry hair suits. Their role was to massage people's heads using aromatic Indian hair products, which people found to be extremely pleasant. Throughout the exercise, race was never overt. It was devised to be a steady sub-text.

First, there was the matter of where power was located. The agenda was set clearly by the black performers. They initiated the action and embodied expertise. In the case of the men, the expertise was based totally on culturally derived skills. The issues centred on identity and race. Whose criteria set the terms of 'beauty'? asked the piece. It counter-pointed the mechanistic claims of the packaged products of the first room – supposedly able to transform the appearance – with the gentle and kindly human contact of the later rooms. The substances used by the two men were not chemical or commercial. They were naturally based and connected with Ayurvedic medicine and the healing arts of massage.

Human hair – at the same time both so strong and so delicate – carried the central theme: so subtle that it could be teased into elegant curls and tresses; so strong that, in the form of a chair, it could support a human's weight. References to 'ethnic' hair were deliberate – the power of Rastafarian locks, the magical nature of Indian women's long hair (shorn off, in orthodox Hindu households, when husbands die). The sessions with both women and men were designed to have a ritualistic quality, almost as if the latent power of human hair was being placated.

It is no accident that Khan designed the space as he did, turning it into something that was neither art gallery nor theatre nor, indeed, beauty salon. A neutral in-between space – with dim and fluctuating lighting that rose and fell – it aimed for imprecision, for ambiguity. That in-between state itself, however, demands emphasis. Not only does it illustrate the elusive area in which Khan's work tends to be sited, but it also has major things to say about the characteristics of cultural work that exists at the perceived margins.

The past twenty years have seen a steady progression of preferred terms, each of which can be unpacked, revealing a wealth of attitudes, prejudices and value judgments. 'Ethnic minorities' communities' arts', the 1976 term, openly identified work by Black artists by its cultural base (and had some justification for doing so at that time) and spelled out what was seen as a narrow base of ownership.

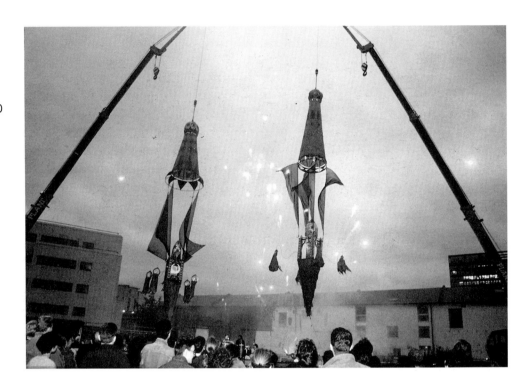

Flying Costumes, Floating Tombs,
London International Festival of
Theatre (1991)

The image is taken from the end of
the performance when the hosay
structures were lifted up by cranes
to reveal the focus of the project.
Hussain and Hassan, two martyred
brothers; red for decapitation, green
for poisoning; creating simultaneous-
ly effigies and formal architectural
sculptures. This was a large-scale
community project performance,
dance, sculpture, costume design
and procession which took place on
the quay outside the Arnolfini,
Bristol and in Paddington, London.
Photo: Ali Zaidi

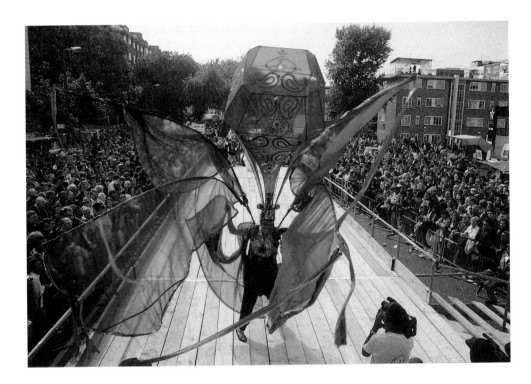

Costume Design, Notting Hill
Carnival (1993)

This costume was made for the
South Connections carnival band
who played 'Before Columbus' which
celebrated the existence of the
nations before Columbus 'discov-
ered' them. The masquerader is Joan
Francis, a nursing sister and a mag-
nificent performer with the kind of
power that is rare. The picture is
taken at the judging point – the only
moment in the day when the band
is lined up in the way that the
designer imagined it. The costume is
more formal than many of mine, but
in a year when I was making and
supervising the making of 200 floor
members and ten individuals, aes-
thetics were carefully balanced with
durability, resistance to wind and the
other practicalities required by a
costume for the road.
Photo: Ali Zaidi

The idea of universality was not broached. This was followed quickly by the less cumbersome 'ethnic arts', which gave a brighter consumer gloss to the arts, connecting them with the 1970s discovery by society of 'ethnic food', 'ethnic dress'. 'Black arts' in the 1980s was a stark statement of resistance and self-definition. The 1990s' coinage, 'cultural diversity', has the double-edged advantage of being all things to all people. But it may, however, herald a time when it proves possible to consider the work rather than the category.

Ambiguity is a good starting-point, for Keith Khan's work demonstrates a condition that is becoming increasingly familiar: a shifting hybridity that politely refuses to sign up to one race or another. The shift in terms and terminology does not denote vagueness, opportunism or fashion. It is a reflection of the number of worlds and agendas to which Black artists (and others) have access. The strength of that cultural location is being able to chose to play with identities – to move from one to the other, from temple to rap, movies to mosque. It is an inspired slipperiness, a conscious rejection of boundaries that no longer serve an immediate purpose and an attitude that creates new concoctions from a mixture of forms. The result can end up as a more faithful reflection of the way in which sensibilities are shaped in this global age than many culturally specific or heritage arts.

Keith Khan has, in effect, been reinventing himself though his work. In early work, like *Flying Costumes, Floating Tombs* (1991), he tended to create images that made overt cultural references. Later work has seen him coming to terms with cultural plurality, and producing lighter, more elliptical pieces. The process of synthesis demands deftness. Khan himself has had to find his own balance between cultural strands. For a start there are influences of varied forms of contemporary western culture – gay culture, club culture, music, dance, video, film. Then there are Khan's own Caribbean origins. His Indian-Muslim family went to Trinidad as indentured labourers in the nineteenth century. Little conscious heritage remains – he goes by Keith rather than his given name of Keith-Aly – but it is still

enough to direct him to Islamic images of Moharram (the month in which the great Muslim martyrs are ritually mourned) in *Flying Costumes, Floating Tombs*. This large-scale piece for out of doors was commissioned jointly by Bristol's Arnolfini Gallery and LIFT'91. Ali Zaidi worked as a key collaborator on this project. Expansive and ambitious, it set out to work across disciplines, using the form of a procession to bring together visual arts, music and dance. At the same time, it deliberately tried to make itself accessible to people who might be deterred by the term 'public art'. In both its showings, in Bristol and London, it was preceded by a community training course which ensured the final involvement of 300 performers. They were trained by Black choreographer, H. Patten, and performed work based variously on Indian, African and Caribbean dance forms.

The involvement of Patten and his skills was significant. Khan deliberately looked for working colleagues and a team-based ethos. The model for this form was Carnival, a Trinidadian product and a pattern to which he has regularly returned. For though the Moharram motif was dominant, the flavour came from Carnival. It looked to that event, and sought to key into a similar expansiveness, exuberance, style, populism and social relevance.

The big costumes that were the trademark of *Flying Costumes* were made to be displayed on the move, processing along the Bristol docks and beside London's Paddington Basin. They embodied Carnival's ephemeral quality – like those costumes, these would be destroyed after the event was over – the antithesis of commercial gallery art. They had been produced by many creative skills, some of them not generally considered art forms: engineering, welding, wire-bending, shaping textiles over steel frames. Finally, they looked to make a clear statement – as Carnival costumes can also – about the world. They talked about migration and mixing, about the transference of cultures from one place to another, about the impermanence of objects but the permanence of values. The hybridity they embodied was an appropriate form with which to mirror the reali-

143

ties all its makers knew intimately and which they negotiated daily. The third of Khan's major influences comes from the Western fine art world. Khan is the product of Wimbledon School of Art and then of Middlesex University where he took a sculpture course. He is at home with art-school language. Exhibitions like *Captives* (1994), on which he collaborated with Ali Zaidi, in Walsall Museum and Art Gallery belong happily in a gallery environment and assume the presence of those conditions – silence, concentration, an opportu-

144

Captives, an installation for Walsall Museum and Art Gallery (1994)

In one space photographic images are printed on to photosensitised bamboo blinds and in another space there are textiles which were produced in collaboration with a team of embroiderers from Lahore. It was inspiring to work with many different people – the woodcarver from Pakistan, the Walsall Illuminations team, and the nursery-men who provided the fish.
Photo: Ali Zaidi

nity for the individual to engage independently with the work rather than experiencing it as part of a moving crowd.

The nature of the audience matters a great deal to Khan. Although he was delighted by the response to *Flying Costumes*, he was unhappy with one aspect. Of the 3000 or so who had been to see it in its two sites, most were white. This concerned him not simply because he, like many artists, wants his work to be widely accessible, but for a reason that was more closely allied to his aesthetic. The absence of Black participants meant the absence of a knowledgeable and empathetic response. The work was based on references and allusions that specifically sprang from the Caribbean. He needed the resonance of an answering sensibility that would catch them.

Without that audience the work existed in a kind of freefall. For although good work transcends culture, the artist also needs to see it grounded in people who share its basic language.

Flying Costumes contributed to Khan's reassessment of his artistic forms. Partly as a result, he turned back to working directly with costume 'bands' at the annual Notting Hill Carnival. He had in fact been designing costumes since 1987, both in Britain and in Trinidad. He had designed for Batimamzelle, South Connections and Yaa Asantewaa and was excited by the roots he could trace, back to India and Africa, for the event. However, Carnival did not match up to its potential. It had settled far too much, he went on record as saying, into an institution, a safe spectacle in which the bands took too few chances and had forgotten their original role of being at the cutting-edge of social comment and creativity. He was getting bored and irritated, he said, with yet more costume bands that honed in on colourful themes of flora and fauna of the Caribbean. Even more to the point, he was getting disturbed by what he saw as the ageing of the event. It failed to involve young people once they entered their teens, attracting them back again only when they had reached the age of nostalgia and their 40s. Surely Carnival, he asked, should by its very nature involve the streetwise young, the vibrant and rude Ragga girls, for instance, who were, in his view, close to the true anarchic spirit of Carnival. Its unsettling and dynamic potential was encapsulated by Michael McMillan in *Cultural Grounding* (1990), his report, for the Arts Council, into Live Art and Cultural Diversity: '[It] has historical and cultural syncretic origins with the Catholic religious celebrations of Lent, and the African cultural form of the talking drum, and tradition of oratory, parody and subversion through the mask/masquerade and the riot'.

It is ironic that theatre — a symbol, too often, of the non-populist and the monocultural — offered him a cure for his frustration. The Theatre Royal, Stratford East, London, which commissioned a show from Khan in 1993, is far from unpopulist and monocultural. With a strong tradition of speaking to and for its local working-class audi-

145

ences, black and white, it was asking for a distinctive show. It was to be called *Moti Roti, Puttli Chunni*, a Hindi phrase that means, 'Thick Bread, Thin Veils'. It is an image that refers to saucy women who are more interested in eyeing men through their scandalously thin veils – the equivalent of short skirts – than in turning out impeccably light chapattis. The show shared the same kind of broad moralising message, but its tongue was firmly in its cheek. For *Moti Roti* was sending up the conventions of the vastly popular Hindi movie form and its world in which the poor are virtuous, the good are chaste and the bad come to a sticky end. It is a world where traditional values, and thick veils, triumph.

Virtue – in the persons of a disinherited widow and her poor but honest daughter – sure enough, triumphed in *Moti Roti* too. Its exuberant cast (including one bona fide Bombay film actor) danced and sang its way through a script that incorporated – as befits an event parodying the film world – a section of filmed footage. Its members were required to master the distinctive style of Hindi film acting. Broad and insinuating, it uses its audience in a collusive way, nudging them with assumptions of shared values.

Moti Roti toured nationally and was well received by Asian audiences (and came to give its name to Khan's subsequent company). The form of its satire was enjoyably cheerful rather than highly original. Critics also liked it, welcoming the emergence of a new show that was accessible across racial lines. It had other advantages for Khan himself. It went some of the way towards meeting his desire to find a style that he described self-deprecatingly as 'a collective expression of a group identity, whatever that is' – one that was 'not precious'. He liked the sense of being 'a hired brush', like hired guns in westerns who are called in by communities to clean up their town: crafting a piece of work that spoke directly to ordinary tastes and sensibilities. The experience confirmed his taste for large and expansive pieces of work.

Although Khan praises the temporary and ephemeral, and likes working with throwaway recycled material, his work is often pre-

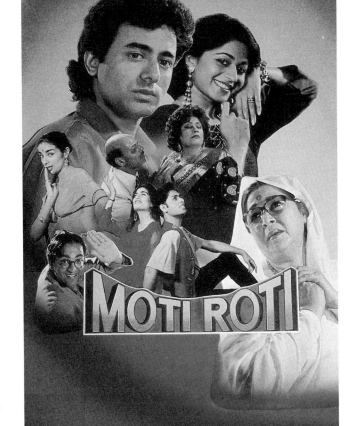

147

Moti Roti, Puttli Chunni, Theatre
Royal, Stratford East and on tour
(1994)

This is the poster for the show and
it was inspired by ideas and images
from popular Indian cinema. It was
deliberately lurid and designed to
have wide appeal. Constructing the
image in this way we hoped to
attract different groupings of people
to the show.
Photo: Ali Zaidi

cise and considered, in a way that is not always observed or credit-
ed. *Moti Roti* was a relatively broad brush and in many ways a learn-
ing process. Khan's design work with London's touring Bubble
Theatre in 1994 and 1995 for their production of *Arabian Nights*
showed his sensitivity to sites and spaces.

The Bubble had taken the bold step of jettisoning the tent in which
it had toured for twenty or so years and which had been its trade-
mark. Instead it set out to 'animate' various London parks during its
summer tour. Director Jonathan Petherbridge devised the produc-
tion so that audiences were induced to follow its action through a

park that was growing darker and darker as evening steadily fell. This planning meant that audience members would suddenly stumble across a new site. They found a small pavilion glowing in the twilight distance, a large square table apparently waiting for a feast. Sets swam out of the darkness and the audience clustered around them, drawn by a quality of magic. The sets did not confront, rather they gently seduced the onlooker. They cajoled and drew their audiences to them, hovering teasingly just on the edge of parody and making a useful context for the caustic insights of Farhana Sheikh's far from romantic script. Khan's role was limited to design, which gave him more freedom. Perhaps for that reason, the stereotypes suggested by the sets were presented with more lightness and delicacy – for all the dark and melancholy undertow – than in the broader *Moti Roti*.

At times, Khan's desire both to please and to expand his boundaries can present dangers. *Maa* (or 'Mother')(1995), which followed *Moti Roti* in the theatre, gave him enormous scope to indulge that generosity. Not only did he devise this show in conjunction with Ali Zaidi, but he also undertook to direct it too. The show was an audacious mix. It had mythic creatures: the eponymous central character's own long-dead female ancestors (a kind of celestial supporters' club), filmic components (melodramatic knifing and a murder), social comment (displacement of Caribbean Indians and the oppression of Asian women), plus a completely riveting quality of razzmatazz in the form of a group of Asian male cross-dressers. Carnival featured in the show – whose storyline ventured from heaven to Trinidad via Britain – and towering Carnival costumes. The ambition of the basic scenario (and a script by Ashish Khotak) guaranteed problems, essentially concerning balance and coherence. But, above all, they highlighted a tension between the product and its context. The expansive mixture badly needed to spill out of the confining Royal Court Theatre's stage; it needed to engage with its audience in a new way. In the parks, people had followed the action around, looking for messages around dark corners and find-

ing them in surprise. A theatre – at least one with a straight prosce-nium arch stage – was too passive and confining. It imposed an aes-thetic that struggled with the possibilities of Khan's own work.

The use of movement finds Khan at his most interesting – whether by docks, through spaces at the ICA or in night-time parks. Conventional theatre spaces, for all his theatricality, do not easily suit. Installations fare better and give him more control over the way in which the audience experiences his work. They also allow his

The Seed, the Root, East London (1996)

One of the sites for this project was the Clifton Restaurant in Brick Lane where recipes were printed on to postcards and given to members of the audience as part of the guided tour. Shams, the manager, is holding a huge silver platter of Bangladeshi vegetables, flanked on either side by Bibi and Begum, his mother and his wife. When I had taken the photo-graph, the family insisted I stay for lunch and out came the *dar* (a curved knife) for slicing and cleaning kokural for the meal. The image so captivated me that in the end two postcards were printed, this being the impulsive, other one.

Photo: Ali Zaidi

quality of precision and his puckishness to thrive.

The Seed, the Root (1995) showed both those well. The event was devised by Khan's and Zaidi's company, Moti Roti, and took as its 'theatre' a large section of the East London area of Spitalfields. The location was well chosen. Brick Lane, and the areas around it, have long been the focus for successive waves of immigration – Huguenot, Jewish and, more recently, Bangladeshi – and also for racist opposition to immigration. *The Seed, the Root* was, amongst other things, an assertion of presence and a quiet statement of territory.

Khan himself was not directly involved: it was set up by Zaidi, in conjunction with Trinidadian artist, Steve Ouditt. But the style of work – playful, responsible and resonant – showed *Moti Roti* in its best light. The art work was seeded around a wide area and had to be sought out. Consequently people found themselves peering into wedding shops and clothiers, hanging round the indoor market and poking around playgrounds. The eight installations were inserted into regular workaday places and spotting them was like a game. They were infiltrators, slipping their messages about religion, gender and race into seemingly innocent shop windows and spaces, calling in musicians, local dancers and restaurateurs to reinforce their themes. Performers left onlookers with a translation of the lyric they had been singing. 'A liar is a magician, a liar is a magician. Beware of him. Keep away from him, and believe him not.'

The variety of techniques in *The Seed, the Root* and other works are a trademark. Their genesis partly comes from a cheerful eclecticism and wit (and the charm of the magician), but we should be clear that something more serious is happening. The characteristic eclecticism forms part of an ongoing search for the tools with which to express identity: neither Caribbean nor Asian, but specifically British, with all the contradictory diversity that the term now implies. It involves a series of cross-references, back and forth, between past and present, then and now, with its energy arising from those minute series of echoes and collisions.

At the same time, Khan's direct references to the past and to race have gradually become less self-conscious. In his Steve Rogers's *Memorial Lecture* (1995), he acknowledged his earlier tendency to 'quotations' – 'direct imitations of cultural icons, lifting powerful images and claiming them within my work, hearing about the past, wishing to place it within the present, accounts for my desire, at the moment, to reach back'.

Khan's work has absorbed personal history over time rather than expunged it, but it still thrives on difference – on the tension between the gallery work and the popular work, between private and public, between timelessness and ephemerality, old art forms such as theatre and new art forms like film. However, Khan embodies a new kind of British sensibility that takes a more straightforward ownership of the concept of cultural diversity, without the angst that previous practitioners expressed. A vague term at its best, the major strength of 'cultural diversity' is the recognition it gives to the existence of a broader palette. Keith Khan's experiments with its possibilities are liberating, teasing and based around a stubborn and insistent commitment to the right to form his own particular identity. Like a magician, he transforms from disparate elements. The fact that he is hard to categorise clearly demonstrates the complexity and subtlety of cultural changes and the dangers of terminology.

Since 1979 Artsadmin has worked with the following artists / companies

Heather Ackroyd & Daniel Harvey
Ali Zaidi – Moti Roti
Axis Mundi
Lucy Bailey & Jane Gardner
Bobby Baker
Blood Group
The Bow Gamelan
Chinook Theatre (Canada)
Committed Artists (South Africa)
Cultural Cooperation
DV8 Physical Theatre
Els Comediants (Spain)
Earth Players (South Africa)
Rose English
Fairground 84
Mike Figgis
Flying Karamazov Brothers (USA)
Forkbeard Fantasy
Forced Entertainment
'Fresh' South East Arts Festival
Hesitate and Demonstrate
Housewatch
Ian Hinchliffe
ICA Theatre Productions
IOU Theatre Company
Impact Theatre Co-operative
Insomniac Ltd
Jail Warehouse
Junction Avenue Theatre Company (South Africa)
Kaboodle
Keith Khan – Moti Roti
La La La Human Steps (Canada)
Rosemary Lee & The Balanescu Quartet
LIFT
Mary Longford
Lumière & Son
Mamu Players (South Africa)

Market Theatre Company (South Africa)
Jacob Marley
Mickery Theatre (Netherlands)
Graeme Miller
Chris Monger
Mrs Worthington's Daughter
Mzwakhe Mbuli (South Africa)
New Moon Theatre Company
New Theatre Productions
The People Show
Pip Simmons Theatre Group
Potemkin Productions
Radeis (Belgium)
Ralf Ralf
Nancy Reilly
Semblance
Steve Shill
Yolande Snaith Theatredance
Andy Smith
Smith and Goody
South East Asian Arts Project
7.84 Theatre Company
Station House Opera
Stein Productions
Gary Stevens
Tarragon Theatre (Canada)
Stephen Taylor Woodrow
Fiona Templeton
That's Not It
The British Are Coming (Denmark)
Simon Vincenzi
Vusisiswe Players (South Africa)
Welfare State International
Zabalaza Festival

Index

156

157